IMAGES
of America

MT. LEBANON

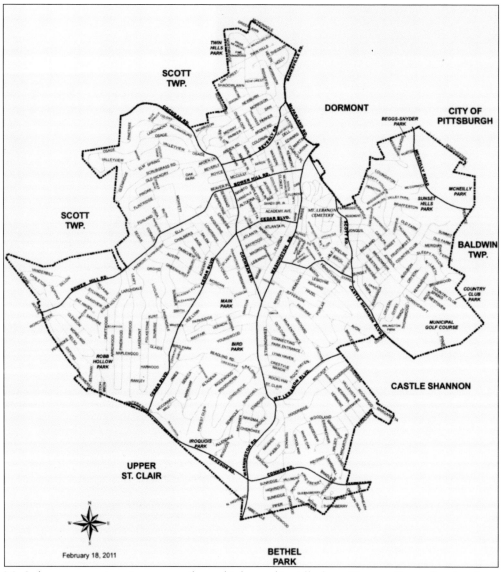

Mt. Lebanon comprises six square miles and is located in Allegheny County, Pennsylvania, about five miles south of Pittsburgh. (Courtesy Michael Meseck.)

IMAGES
of America

MT. LEBANON

Historical Society of Mount Lebanon

ARCADIA
PUBLISHING

Published by Arcadia Publishing
Charleston, South Carolina

Printed in the United States of America

Library of Congress Control Number: 2011921022

For all general information, please contact Arcadia Publishing:
Telephone 843-853-2070
Fax 843-853-0044
E-mail sales@arcadiapublishing.com
For customer service and orders:
Toll-Free 1-888-313-2665

Visit us on the Internet at www.arcadiapublishing.com

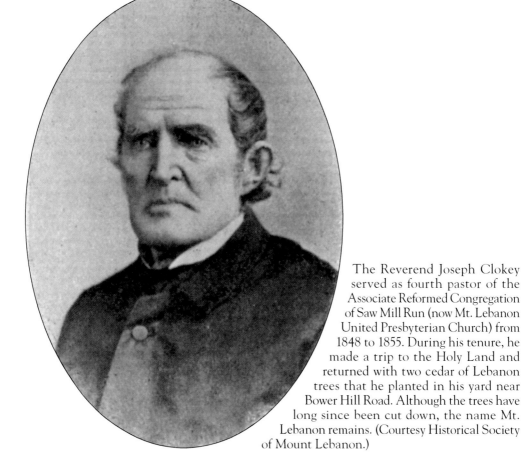

The Reverend Joseph Clokey served as fourth pastor of the Associate Reformed Congregation of Saw Mill Run (now Mt. Lebanon United Presbyterian Church) from 1848 to 1855. During his tenure, he made a trip to the Holy Land and returned with two cedar of Lebanon trees that he planted in his yard near Bower Hill Road. Although the trees have long since been cut down, the name Mt. Lebanon remains. (Courtesy Historical Society of Mount Lebanon.)

CONTENTS

Acknowledgments 6

Introduction 7

1. People 9

2. Homes and Neighborhoods 21

3. Schools 39

4. Sports and Recreation 51

5. Businesses 63

6. Municipal Government, Churches, and Organizations 79

7. Community and Events 95

8. Scenes 111

ACKNOWLEDGMENTS

The Historical Society of Mount Lebanon is fortunate to have in its collection a wide variety of photographs donated by past and present residents, as well as collections from the Bryson Schreiner and Roy C. Dear estates, the Mt. Lebanon Public Library, *Mt. Lebanon* magazine, and the Mulert family. Except where noted, all images in this book came from the society's collection, the Mt. Lebanon Municipality (thanks to municipal manager Steve Feller, Rudy Sukal, and Keith McGill), the Mt. Lebanon School District (thanks to Cissy Bowman and Carlie McGinty), the Mt. Lebanon Fire Department (thanks to Chief Nick Sohyda and Ed Davies), and the Mt. Lebanon Police Department (thanks to Chief Coleman McDonough and Jamie Hughes).

We would like to thank the following people for assisting in the production of this book: *Mt. Lebanon* magazine editor in chief Susan Morgans and staff, Bill Metzger, Jennifer Rignani, Phyllis Moore, Bud Stevenson, Scott Jackson, Gwyn Cready, Dormont Historical Society president Muriel Moreland, Marilyn Walsh at the Baptist Homes, and Mt. Lebanon Public Library director Cynthia Richey and her staff. A special thanks to everyone who provided pictures. If your name was omitted, it was unintentional, and we beg your forgiveness.

For technical assistance and proofreading, we would like to thank Judy Macoskey, Jim Renckly, Mark Johnson, Mark Reis, Merle Jantz, Lee Maddex, Mel Bickel, Cissy Bowman, Richard Price, Lucille Heckman, and Rita Levine. Our wonderful corps of volunteers who ran things while this book was being compiled deserves a heartfelt mention as well.

It must be noted that society president M.A. Jackson did the bulk of work on this book—seeking photographs and organizing them, as well as researching and writing the text and captions.

Finally, the Historical Society of Mount Lebanon Board and its volunteers would like to thank everyone who has supported the society. We dedicate this book to the people of Mt. Lebanon from yesterday, today, and tomorrow. Without the perseverance, ingenuity, and devotion of our residents, Mt. Lebanon would not be the incredible place that we all so dearly love.

INTRODUCTION

Mt. Lebanon is a six-square-mile suburb located about five miles south of Pittsburgh, Pennsylvania. The land that is now Mt. Lebanon was originally home to the Delaware and Shawnee tribes and, later, the Iroquois Confederation, and it is believed that Washington Road was once an Indian trail. The 1768 Treaty of Fort Stanwix acquired land from the confederation (also known as the Six Nations) that included western Pennsylvania and opened it up for European settlement. The predominantly Scots-Irish pioneers who first settled here farmed the land, producing rye and corn that they distilled into whiskey because it was easier to transport than grain. When, in 1794, the government tried to institute a tax on whiskey, area farmers revolted in what has become known as the Whiskey Rebellion. Although the main skirmishes in the insurrection occurred just outside what is now Mt. Lebanon, the farmers whose land was here could not help but be involved, as their livelihood was at stake.

By 1883, Pittsburgh Coal Company and other coal companies established mines south of Pittsburgh, many in what we now call the Beadling area, and began extracting coal from beneath most of the South Hills. Still, the terrain—specifically, Mount Washington—that separated the area from Pittsburgh played a large part in keeping Mt. Lebanon predominantly rural. In 1874, a group of local businessmen created Mt. Lebanon Cemetery along Washington Road, the community's main thoroughfare, because the land was "properly protected against the tumults of trade, the intruding foot of commerce, and the encroaching tide of population."

Although the Pittsburgh Southern, a narrow-gauge railroad, served the area between 1878 and 1883, it was the July 1901 arrival of the streetcar that spurred development. Within four months of the trolley line's completion, the first real estate subdivision—the Mt. Lebanon Plan—was laid out. By 1905, no less than 11 subdivisions had been approved within the future boundaries of Mt. Lebanon. Even so, Mt. Lebanon remained a small, mostly rural community. Ferne Horne, who grew up in Mt. Lebanon in the early 1900s before the community had a high school, recalled in a memoir that when she and her classmates arrived via trolley for classes in Pittsburgh, the city kids referred to them as being from "cow town."

Then, in 1924, the Liberty Tunnels opened. Suddenly, a rapid commute to Pittsburgh was possible; the population soared. Between the 1920 and 1930 censuses, the township's population jumped from 2,258 to 13,403. Housing plans, many designed by forward-looking and progressive planners and architects, began taking over the farmland. Four major business districts sprung up, and roads were paved. In fact, all of the major traffic arteries in present-day Mt. Lebanon have at least some vestiges of these 1920s residential subdivisions. Houses were designed with the automobile specifically in mind during the 1920s, and the garage became an important element in the suburban landscape. Thanks to these factors, Mt. Lebanon became a premier example of an automobile suburb.

In addition to its award-winning schools, Mt. Lebanon is probably best known for its beautiful and varied architecture, including Tudor, Colonial, Georgian, Spanish eclectic, bungalow, and

other styles. The Pittsburgh History & Landmarks Foundation recently named Mt. Lebanon's Art Deco municipal building completed in 1930 a historic landmark. The Mt. Lebanon Golf Course, one of the oldest in the area (the first game was played there on July 4, 1907), also received historic landmark designation.

Mt. Lebanon was originally part of St. Clair Township, then Upper St. Clair Township, and in 1861, Scott Township. On April 17, 1909, the *South Hills News* ran a story stating that the "progressive citizens of Mt. Lebanon" wanted to break from Scott Township because the seat of government—four miles distant—did not thoroughly understand the needs of the territory. "It is maintained," the article read, "that by a tax rate even lower than Scott Township's, the district can put in street crossings, construct several miles of boardwalks, erect and maintain streetlights, furnish police and fire protection, improve schools, etc." Even then, it took three elections to get the unanimous vote needed for secession. On February 6, 1912, Mt. Lebanon became a township of the first class. At the time, the designation was a relatively new concept that meant the community would include a large portion of undeveloped land and would be run by an elected commission. (In 1974, Mt. Lebanon became a home-rule municipality.)

When formed, the new community had 1,705 residents, 75 gas streetlights, two schools with approximately 200 students (the school district was formed the same year), six automobiles, and one fire hydrant.

Today, the community boasts almost 33,000 residents, a state-of-the-art public safety center that houses the police and fire departments, seven elementary schools, two middle schools, one high school, two parochial schools, recreation facilities, lovely parks, fabulous housing stock, 14 churches, two synagogues, and, of course, many, many cars.

The Historical Society of Mount Lebanon has tried to capture a portrait of Mt. Lebanon and its history in these pages. But 227 pictures does not even scrape the surface of the community's rich 100-year history, much less that of the residents, businesses, neighborhoods, schools, places of worship, and many organizations that have made—and continue to make—our community home.

One

PEOPLE

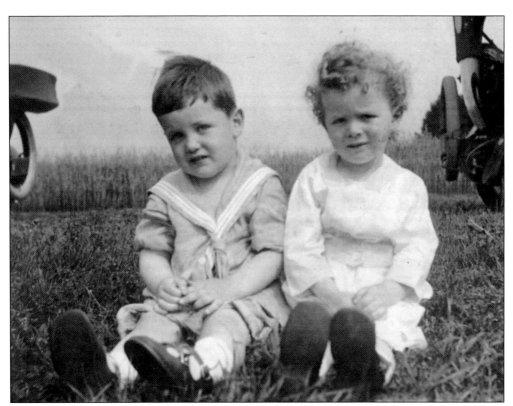

C. Bryson Schreiner (left) and Willis Seigfried, two Mt. Lebanon scions, enjoy a church picnic around 1915. Their fathers—Samuel and Willis, respectively—were instrumental in separating Mt. Lebanon from Scott Township in 1912. For many years, Schreiner's father served as township and school district solicitor, and Seigfried's father was a school board director and one of the township's first commissioners. These youngsters followed in their fathers' footsteps, serving the community.

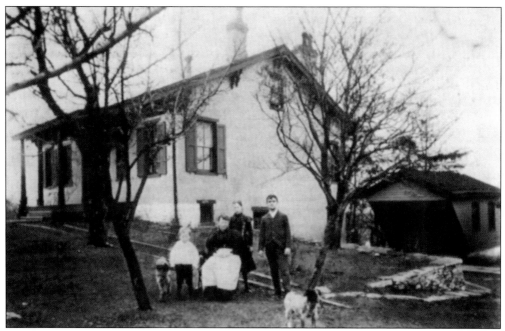

The Bailey family stands outside their home on the corner of Washington and McFarland Roads in 1895. Andrew McFarland had purchased the land from the Penn family in 1773; the house was erected in 1836. The little boy in the picture is Charles "Pap" Bailey, who opened what is said to be Mt. Lebanon's first gas station, adjacent to the house, in 1920. The house was torn down in 1945.

Cyrus "Old Doc" Schreiner was one of the area's first doctors, practicing from 1877 until his death in 1900. He and his wife, Myrtilla, lived at the corner of Washington and Bower Hill Roads with their 10 children.

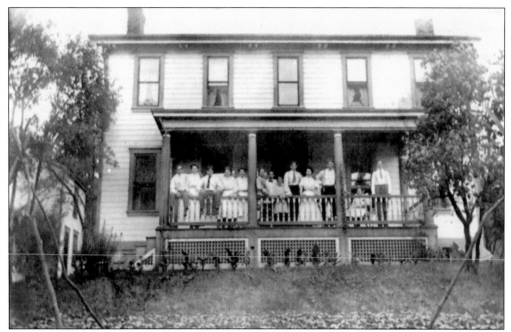

Built in 1856 and surrounded by strawberry, daisy, and grazing fields, the Abbott farmhouse was located in what is now the Beverly Road area—Lincoln School was later built on what was the Abbott's pasture. This family picture was taken around 1905. In 1926, Edward Abbott Jr. (far left) sold the land to a developer and moved to a house at 278 Beverly Road. (Courtesy Janice Donley.)

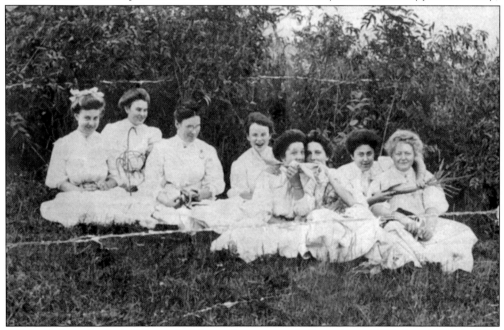

All decked out in their Gibson Girl best, these young ladies enjoy a 1901 church picnic. The girls are, from left to right, Birdie Fox, Ada Martin, Mrs. Gilfillan, Agnes Gilfillan, Lil Meyers, Gladys Wiletts, Bessie Goodboy, and Phoebe Alderson. Bessie was the daughter of Mt. Lebanon Cemetery caretaker Jake Goodboy. (Courtesy Bill Goodboy.)

Jacob Gutbub sits outside the cemetery gatehouse where his son Jacob Goodboy lived. In 1864, Gutbub had purchased seven acres between what is now Beverly and Bower Hill Roads. When he wasn't away working as a riverboat steward, Gutbub farmed the land with his wife, Catherine, and raised seven children. This picture was taken around 1910. (Courtesy Bill Goodboy.)

Thomas Milton McCormick (second from left) grew up on what is now Kenmont Avenue. (His father, Dr. Joseph McCormick, came to the area in 1857.) McCormick, a schoolteacher, built this house at Washington Road and Hazel Drive around 1880 when he married Nancy Fife. Jake Miller, the hired man, holds the horses; Nancy stands; and McCormick's sisters Ida (left) and Martha sit sidesaddle. The house stood until the 1950s.

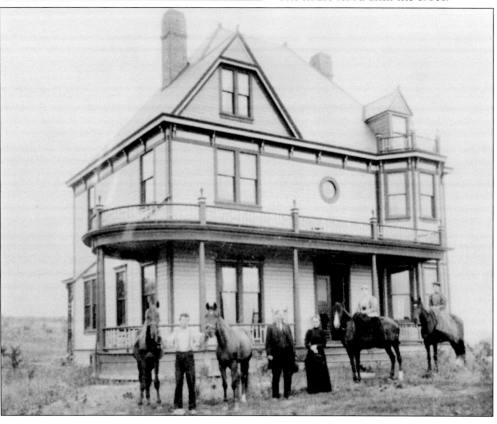

The Mulert family poses outside their 842 Washington Road house in 1909. Although the founding of Mt. Lebanon was three years away and the Liberty Tunnels 15 years in the future, Justus Mulert (fourth from left) was so confident in the community's future that, in 1902, he began developing the Clearview Plan of lots along the west side of Washington Road, between Cedar Boulevard and Cochran Road.

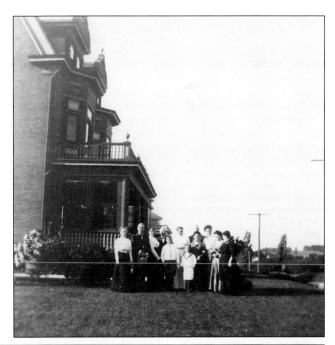

The children of Dr. Cyrus Schreiner and his wife, Myrtilla (seated, center), pose with their spouses at Myrtilla's 16 Bower Hill Road home around 1930. Standing are, from left to right, Guy and Laura Schreiner Wallace, Guthrie Reed Schreiner, Virginia Schreiner, Carolyn Schreiner Cort, Adella Schreiner, Agnes Schreiner Charters, and Robert Charters; seated are, from left to right, Samuel Schreiner and wife Mary Cort, Myrtilla, and Hallie Schreiner McCown and her husband, J. Oscar.

Standing outside their 111 Bower Hill Road home in September 1924, the McMillan family is, from left to right, Grace, Louise, A.C., Paul, Clarence, and (in front) Charles. A.C. served 30 years on the Mt. Lebanon School Board, 25 of which were as president; Louise was a founder and president of the Women's Auxiliary of Goodwill Industries; and Grace, who lived in the house until her death, was a well-loved piano teacher and played organ at Temple Emanuel for almost 40 years. (Courtesy Jean McMillan.)

In 1906, Mary Haller moved into a house on Washington Road with her husband, Samuel. When she died in 1940, her obituary called her the "first lady of Mt. Lebanon" because she dabbled in real estate (laying out the Hoodridge area with son Joe), owned a car dealership, and was instrumental in the formation of St. Bernard Church, having hosted the first church service in her carriage house on August 31, 1919.

The 18-room Cipriano mansion at Altoona Place and Cochran Road once comprised three and a half acres, including tennis courts, a barn with ponies, a fishpond, and grape arbors. Rocco Cipriano, who developed the land around the home, bought the house in 1927, and the family lived there until 1949. From left, Cipriano's daughters—Teresa, Gennivi, Tina, and Leona—pose with their aunt Grace. The girls' brothers stand in the background.

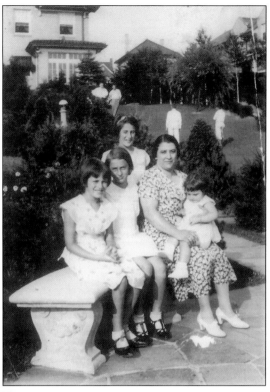

Businessman Joseph Atria opened a grocery store in 1930 on Beverly Road. Local children came here for penny candy and ice cream. When prohibition ended, Atria added a beer garden. Although the store burned down in August 1951, it was rebuilt and later became a restaurant.

15

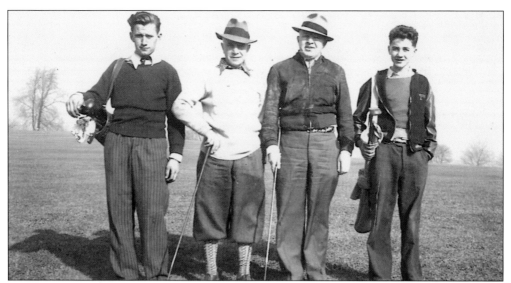

Clarence Scheck (second from left) and Fred Harlan stand between two unidentified caddies at St. Clair Country Club on December 25, 1940. Scheck was the first president of the Mt. Lebanon Commission and served five terms. He lived at 181 Cochran Road with his wife, Maude, and son, Alan. Maude directed the Mt. Lebanon Junior Red Cross during World War I. (Courtesy Joy Pajak.)

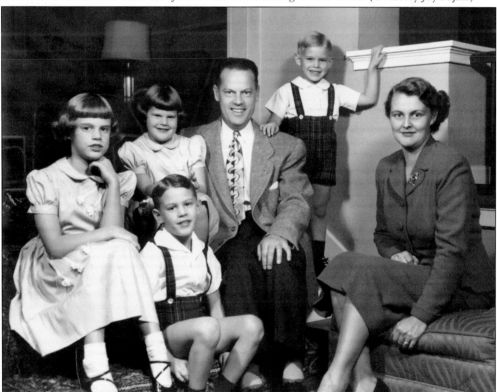

Dr. Donald McMillan maintained an office in the basement of his home at 794 Washington Road. For many years, McMillan was the school football team's physician. McMillan and his wife, Christina, pose in the 1940s with their children (from left) Ann, William, Jean, and Richard.

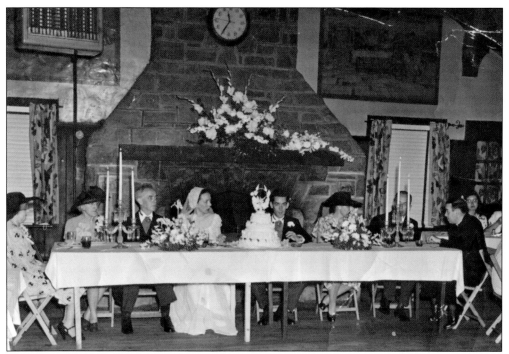

Clare ("Mick") and Eleanor McDermott held their June 7, 1947, wedding reception at the Lebanon Lodge at Washington and Connor Roads. Pictured here are, from left to right, Helen O'Donovan, Katherine O'Donovan, Clare McDermott Sr., Eleanor, Clare, Gladys Hatch, Larry Hatch, and Father Wyrech. (Courtesy Maggie McDermott.)

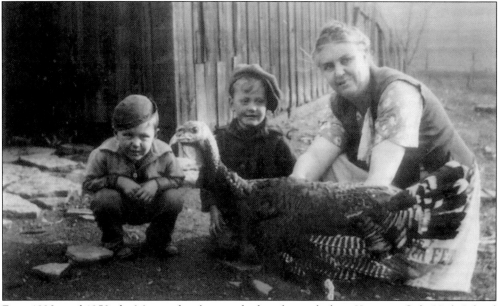

From 1890 until 1950, the Morton family owned a farm located where Keystone Oaks High School now stands. Drivers on McNeilly Road often saw Charley the horse roaming the pasture. Here, Mary Ann Morton and grandsons Fred Meyers (left) and Tom Madden get ready for Thanksgiving. (Courtesy Bill Madden.)

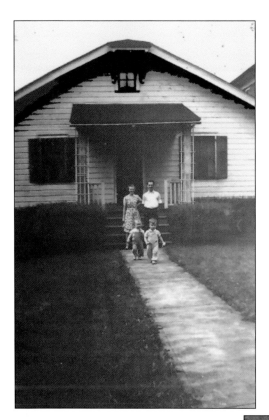

Standing outside their 240 Academy Avenue house in 1943 are Florence and Leslie Taylor with their twins, Nancy and Robert. The family had recently moved to Mt. Lebanon from Overbrook. (Courtesy Robert Taylor.)

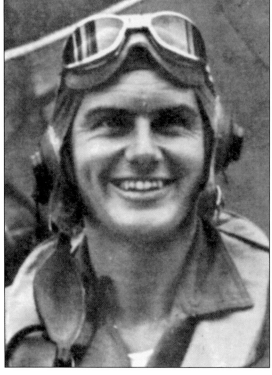

Capt. Paul Mullen grew up on Ordale Boulevard and graduated from Mt. Lebanon High School in 1936. In 1942, after graduating from Notre Dame, he enlisted as a naval aviation cadet and eventually became a Black Sheep Squadron member. He died on February 12, 1946, when, during a routine training flight, his plane collided with another plane. Of the 2,644 Mt. Lebanon GIs who served in World War II, 65 never returned.

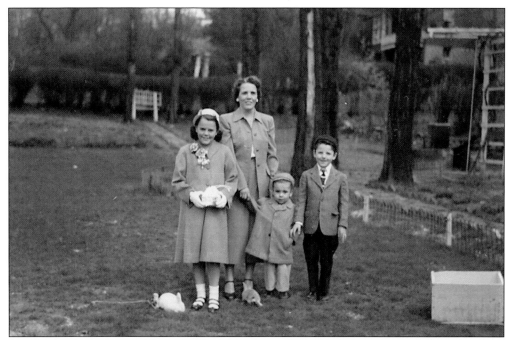

Standing in the backyard of their 610 North Meadowcroft Avenue house in 1950, the Dorans—from left to right, Sheila, mom Julia, Dennis, and Terry—celebrate Easter with some bunnies. The house has belonged to the Doran family for five generations. (Courtesy Terry Doran.)

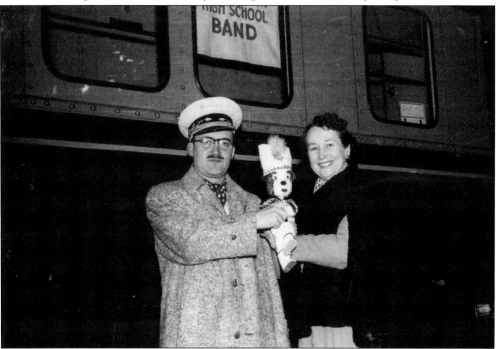

Philip Prutzman and his wife, Eleanor, pose next to the train that took the Mt. Lebanon Marching Band to Dwight D. Eisenhower's inaugural parade in 1953. Prutzman led the band from 1947 to 1965, and few of his pupils will ever forget the spittoon he kept in the corner of the band room.

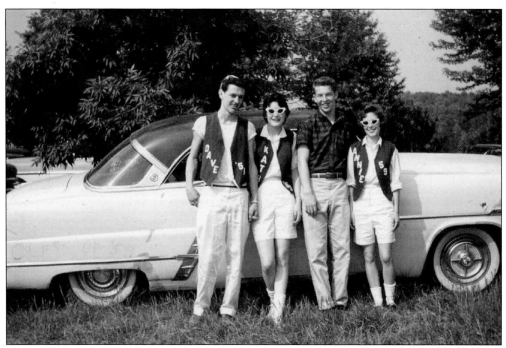

High school students celebrate senior day in 1959. From left to right are Dave Royer, Kathleen Allen, Don Stocker, and Annette Galluze. Vests, jackets, and caps were a tradition for seniors for many years at Mt. Lebanon High School. (Courtesy Phil Mathewson.)

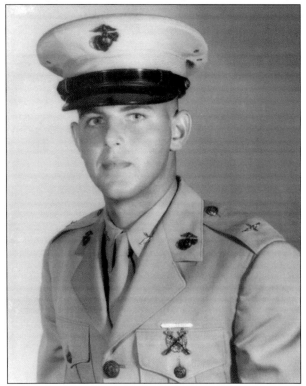

In 1966, Lt. Thomas A. Bird Jr. became the first Mt. Lebanon resident to die in the Vietnam War after his helicopter was shot down during a fight for a Vietcong command post. Bird grew up on Colonial Drive, and his father owned the Cochran Road Esso gas station. He was posthumously awarded the Distinguished Flying Cross. In 1967, Bird Park was dedicated in his honor.

Two

HOMES AND NEIGHBORHOODS

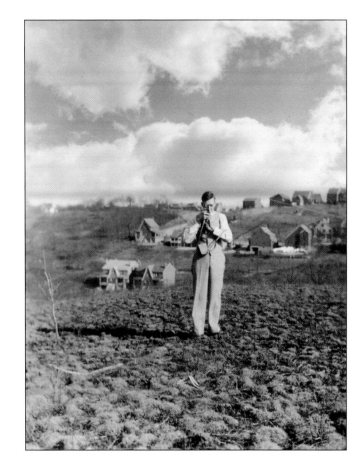

Surveyors like this unidentified man were common in Mt. Lebanon during the early 1900s. Shortly after a streetcar line started in 1901 between Pittsburgh and Mt. Lebanon, the first real estate subdivision, the Mt. Lebanon Plan, was laid out along parts of Shady Drive, Academy Avenue, and Cedar Boulevard. It was the first of many developments that would spring up in the next few decades.

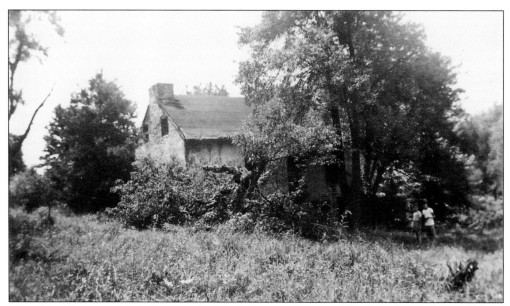

The oldest house in Mt. Lebanon, the Hugh Jackson house on Orchard Lane, dates to about 1808—though it could from as far back as 1794, having been mentioned in reports of the Whiskey Rebellion. The land surrounding the house was part of the original land grant deed dubbed Virtue Hall and issued to William Richardson in 1785 for 270 acres. The house has been renovated since this picture was taken.

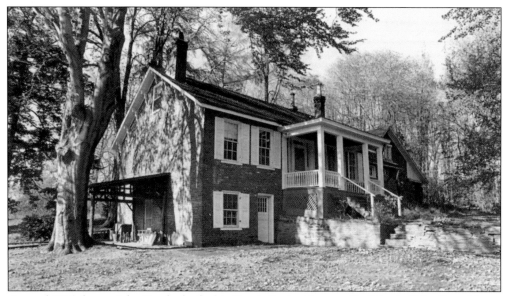

Around 1835, farmer John Snyder built this Greek Revival house off of Shady Drive East. Henry Bockstoce purchased the house in 1854 and ran a nursery and orchard before selling the land to the Mt. Lebanon Cemetery Association in 1874. Congressman Jim Fulton owned the house for a time; it was razed in 1991 to make room for the Main-Line condominiums.

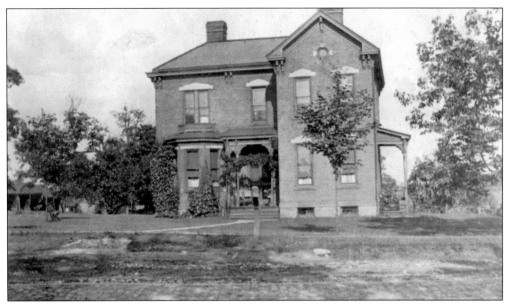

The original Mt. Lebanon United Presbyterian Church parsonage on Washington Road was erected for the Reverend John Boyd, who served the church (then known as St. Clair United Presbyterian) from 1858 until his death in 1903. The church is on the left, out of frame.

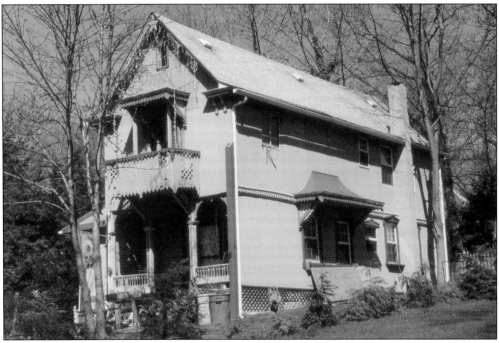

The Arlington Park neighborhood was developed about 1874 as the Castle Shannon Camp Meeting Ground (later changed to Arlington Camp Meeting Ground), a 10-acre summer retreat for Methodists. The local railroad brought thousands of people there for weekly summer revival meetings headed by itinerant preachers in a centrally located tabernacle until the campground closed in 1885. Of the carpenter Gothic-style and vernacular cottages of the late Victorian period built in the neighborhood between 1895 and 1905, ten still exist.

The Kulhman house stood at 731 Washington Road. In January 1920, four and a half acres of the Kulhmans' orchards fronting Washington Road were purchased and leveled to make way for Washington School. The Bognar building was later erected on this spot.

This c. 1900 photograph taken from Shady Drive East shows the back of the Mt. Lebanon Cemetery gatehouse and its outbuildings (at right). The house was built about 1874. From 1899 until 1945, cemetery caretaker Jake Goodboy and his wife, Isadora, could often be found on the front porch swing, where people strolling by would join them to share gossip and watch the streetcars pass.

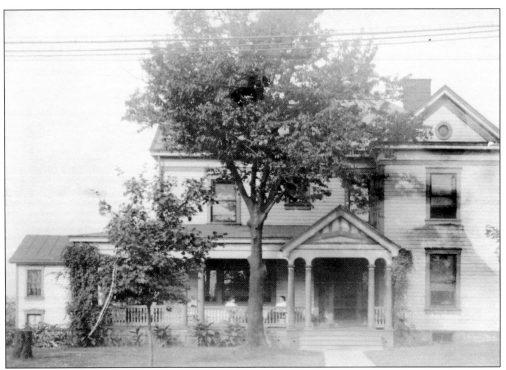

In the late 1880s, Dr. Cyrus Schreiner purchased three acres for $850 at the corner of Washington and Bower Hill Roads and built this house. A side entrance (not visible) on the left was used as the entryway to the doctor's office. The house was razed in August 1929.

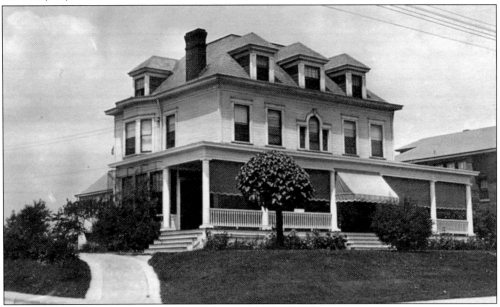

The Haller home stood on Washington Road where it intersects Academy Avenue. The house later became Freyvogel's Funeral Home. After it was razed in 1959, the land was used as a parking lot until the Satterfield family purchased the property and built Rollier's Hardware. This picture was taken about 1910.

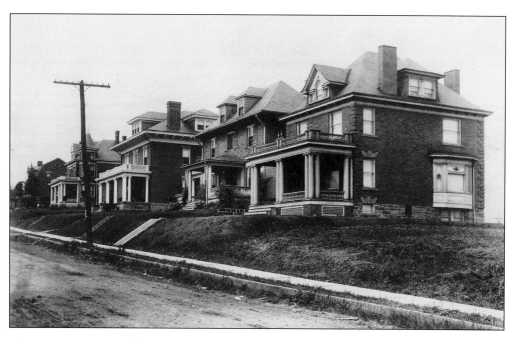

The above picture was taken in the early 1900s on Washington Road just south of Lebanon Avenue. At the time this picture was shot, the houses were owned by, from left to right, the Mulerts, the Clattys, David Yost, Bob Kelly, and the Opfermans. (The Mulert house is now an apartment building.) Looking out their back windows, they would have enjoyed a country vista like the one below, which shows the back entrance of 741 Florida Avenue as viewed from Washington Road. A Mr. McLane built the house around 1910, and the Pierce family lived there for 37 years, starting in 1967. (Below, courtesy Marcia Pierce Kauffman.)

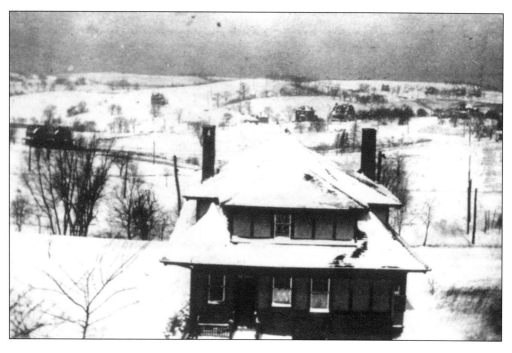

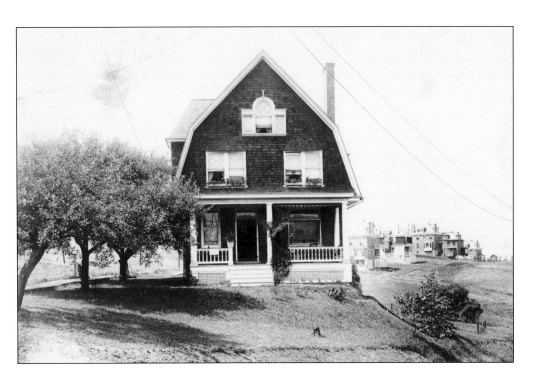

The construction of Justus Mulert's Clearview Plan, which encompassed the land between Cedar Boulevard and Cochran and Washington Roads, started in February 1902. Above is a model Clearview home. Below, these Clearview Plan houses, at the corner of Cochran Road and Cedar Boulevard looking toward the high school, still stand.

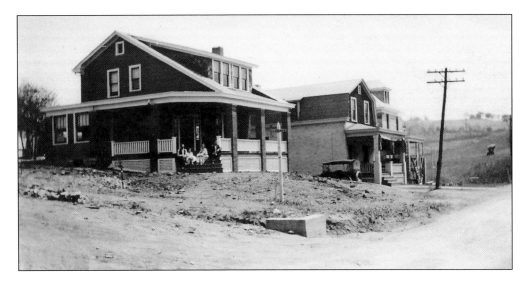

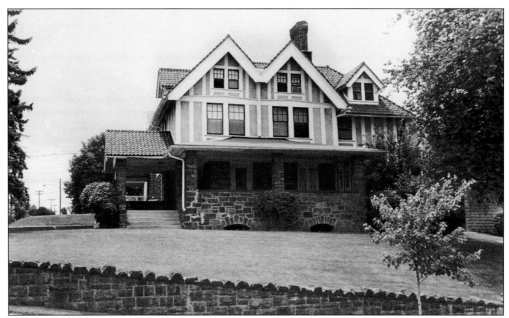

Known as the Evelyn Nesbit house after the infamous Gibson Girl who drove Henry K. Thaw to murder architect Stanford White, this home at Lebanon Avenue and Washington Road was built by Evelyn's mother in 1915. Evelyn's son lived there for a few years, and she often visited him. It is said Leo Haller, whose family owned an automobile dealership down the road, taught Evelyn how to drive a car.

In 1920, businessman Joseph Roush built the 20-room Sunnyhill mansion at the corner of Washington Road and Sunnyhill Drive. He hired the Olmsted Brothers—sons of Frederick Law Olmsted, the most famous landscape architect in the country—to design the 11-acre grounds. Roush developed other areas in Mt. Lebanon and would later serve as a Mt. Lebanon commissioner. The house is now a Unitarian church.

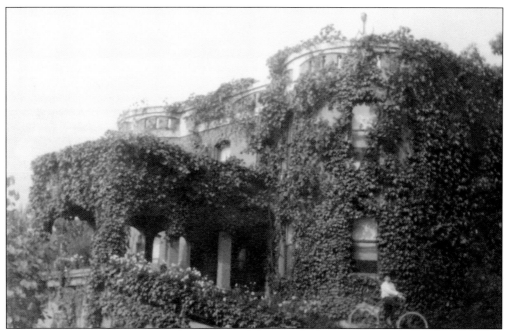

Attorney Andrew Gilfillan Smith built the "Smith Castle" (above) about 1910. It was one of the first concrete, steel-reinforced houses in the country. Located on a private lane off of Cedar Boulevard, the front porch provided a bucolic vista (below).

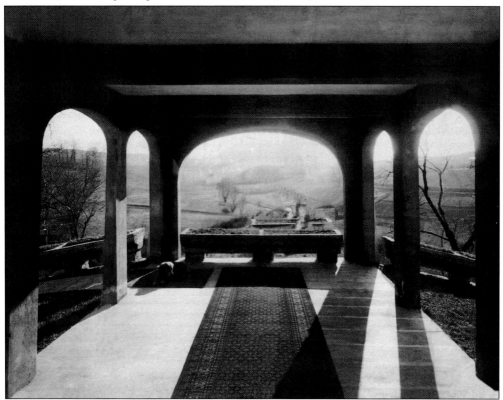

Charles W. Sawhill built this bungalow-style house at 610 Royce Avenue in 1921. Diane Oettinger, Sawhill's great-niece, remembers the house's coal cellar and a garden with cabbages. A portion of the orchard still remains, with cherry, plum, and apple trees. (Courtesy Diane Oettinger.)

Stevenson, Williams, and Johnston Realtors began developing a former dairy farm and orchard into the Mission Hills Plan in 1922. Roads followed the rolling contours of the land rather than a grid pattern, and it was the first subdivision east of the Mississippi to use rolled curbs. The developers' decision to sell land (as opposed to houses) resulted in a diversity of architectural styles—at least 50 different architects and contractors designed houses in Mission Hills. (Courtesy Paul Dudjak.)

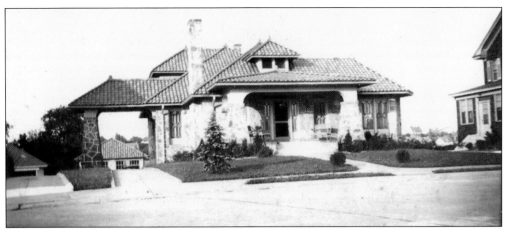

This "ideal bungalow," according to newspapers at the time, located at 153 Main Entrance Drive was a display house furnished by Kaufmann's Department Store. After it opened for tours, more than 60,000 people viewed it and signed the register. Lawyer John B. Nicklas Jr. purchased the house and lived there with his family from 1927 to 1942, when they moved to Virginia Manor. (Courtesy Virginia Nicklas.)

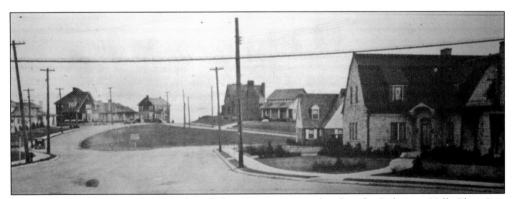

In the 1920s, F.E. McGillick purchased about 100 acres to develop the Lebanon Hills Plan. Lot sizes and architectural styles varied along the rolling hills. This picture shows Main Entrance Drive to the left; Lebanon Hills Drive goes off to the right.

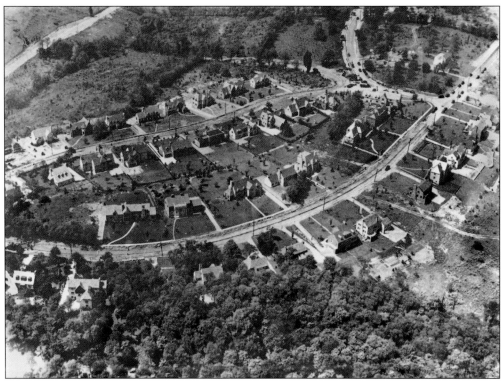

This c. 1940 picture shows the first circle of Virginia Manor. Osage Road is in the foreground; Scrubgrass Road is in the upper left corner. In 1907, Charles Pulman operated a greenhouse in this area. He later sold the land to James Duff, who developed the first Virginia Manor plan in 1926. Architect Tom Garman, who designed more than 2,300 Mt. Lebanon houses, supervised the creation of Virginia Manor's second phase.

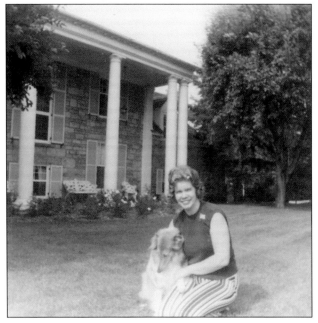

Tom Garman designed this house at 910 Osage Road for John B. Nicklas Jr., a prominent attorney, and his wife, Dorothy Stewart Nicklas. Ground was broken on December 6, 1941—the day before the Pearl Harbor attack. Since all the building materials had been purchased, construction proceeded. The family moved into the house on August 15, 1942. Pictured here in 1972 is John and Dorothy's daughter Virginia with Whimsy the dog. (Courtesy Virginia Nicklas.)

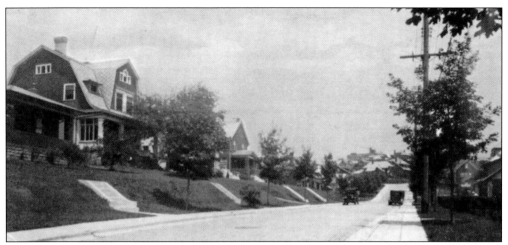

This picture was taken in the 1920s looking up Cedar Boulevard toward Washington Road near the intersection with Old Orchard Place. Mapleton Avenue is just out of sight at left. (Courtesy Paul Dudjak.)

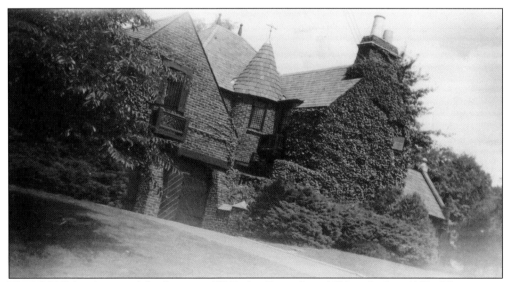

The McFall family owned this house at 420 Parker Drive from 1933 to the late 1970s. This picture was taken in the 1940s. After the McFalls sold it, the house was razed and a new one was built on the property. (Courtesy Sally McFall Moore.)

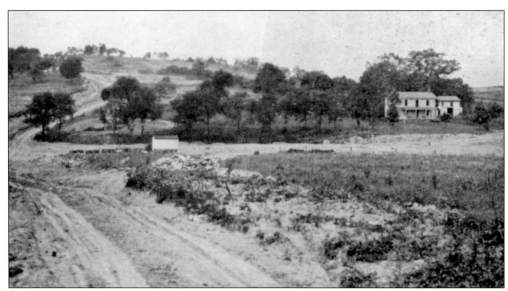

This photograph of Parker Gardens development, taken from McFarland Road on July 1, 1924, was included in a brochure that promoted the W.A. Bode and Company's new development. With houses starting at $590, it was billed as one of the community's more affordable neighborhoods. The Kennedy farmhouse, which still stands on Dan Drive, is at right.

Houses built in the Beverly Road area were part of a community-wide building boom that helped Mt. Lebanon earn a fourth-place ranking (out of 78 municipalities reporting) in the number of homes erected in Pennsylvania in 1936. This photograph of 112 Overlook Drive was taken about 1935.

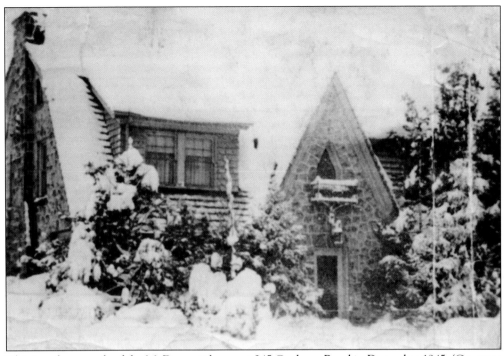

This is a photograph of the McDermott house at 245 Cochran Road in December 1945. (Courtesy Maggie McDermott.)

Architect Clyde McGann designed this house at 57 Marlin Drive.

This c. 1924 photograph shows the entrance to Sunset Hills at the intersection of Sunset Drive, Scott Road, and Castle Shannon Boulevard. W.A. Bode and Company developed the area in three sections in 1922, 1923, and 1928. The W.E. Daum house is at left; Bode's stone bungalow is out of the frame to the right.

This photograph of the home of Leon Drake was taken on Gypsy Lane in the early 1940s. (Courtesy Helen Drake Betzler.)

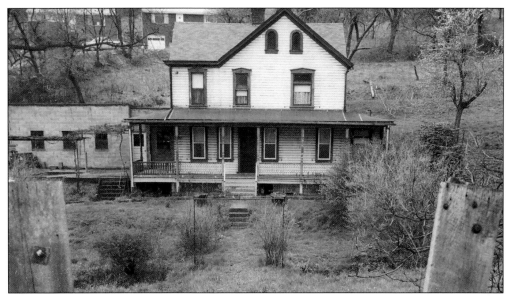

Standing at the border between Mt. Lebanon and Castle Shannon was the Riehl farm, located at 934 Rockwood Avenue. Leonard Riehl, who died in 1937, was a justice of the peace in Scott Township. His farm featured a grape orchard and a creek that ran to Route 88. Riehl's son Walter was a burgess in Castle Shannon from 1938 to 1945. The house was torn down in the 1980s.

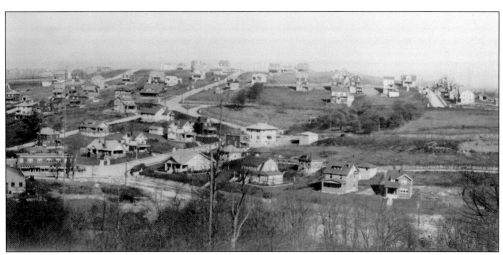

This undated photograph of the Sunset Hills area shows the beginning of the Castle Shannon Boulevard business district (left foreground), as well as Sunset Drive. Fruithurst Drive can be seen in the upper right of the photograph.

This September 1961 picture is of houses along Robb Hollow Road at Larchdale and Arrowood Drives.

Until 1950, the area now known as Carleton Manor was part of Scott Township. A group of residents, convinced they could get more for their tax dollars in Mt. Lebanon, pressed for annexation. Once the area was incorporated into Mt. Lebanon, development took off, with construction including Temple Emanuel and the Bower Hill Apartments. Shown here is Vanderbilt Drive, which was developed from the early 1970s through the early 1990s.

Three

SCHOOLS

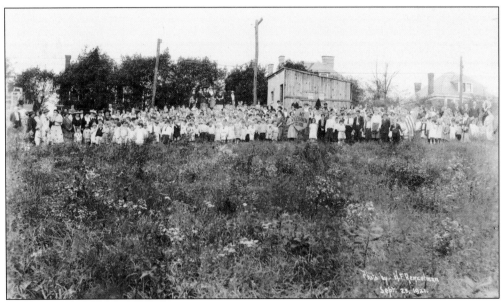

Although some thought Washington Public School was a wasteful extravagance and argued that the rural Mt. Lebanon would never need such a large school, a ground-breaking ceremony was held on September 28, 1921. The school opened the next year, with about 400 students enrolled. By 1925, when Lincoln Elementary opened to handle a steadily increasing student population, enrollment stood at 765. By 1932, that number had grown to nearly 3,000.

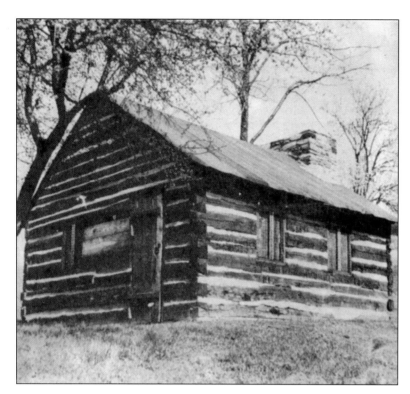

The Higbee School was built in 1794 in what is now Upper St. Clair. It is said to be the first schoolhouse "west of the Alleghenies." In the 1930s, the Mt. Lebanon Lions Club moved the building to Mt. Lebanon Park and opened it as a teen center. It was razed in the 1950s.

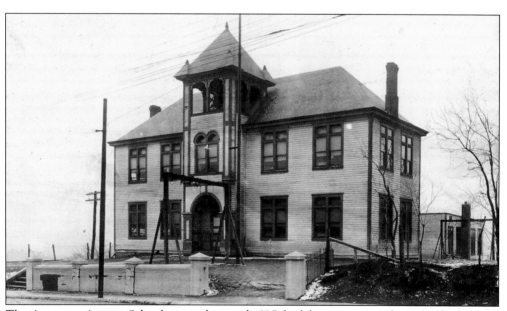

The Ammann Avenue School, erected around 1895, had four rooms, outdoor plumbing, and a bell tower, where custodian Thomas Roach rang the bell every morning. The school also served other purposes—on February 6, 1912, the newly formed Mt. Lebanon commission met in the boiler room to prepare a charter for the new township.

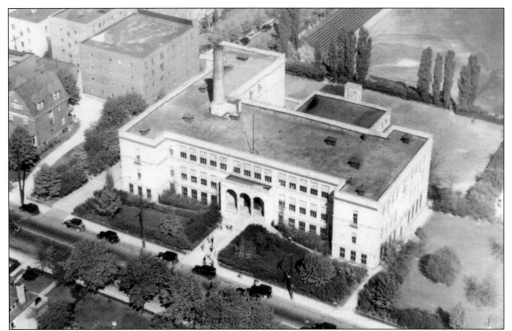

Charles Tattersall Ingham and William Boyd Jr. designed Washington (pictured), Lincoln, Howe, and Markham Elementary Schools, Mellon Junior High, and the high school. Landscape architect Tell William Nicolet, who lived on Parker Drive, designed the grounds around both Washington and Lincoln Elementary Schools.

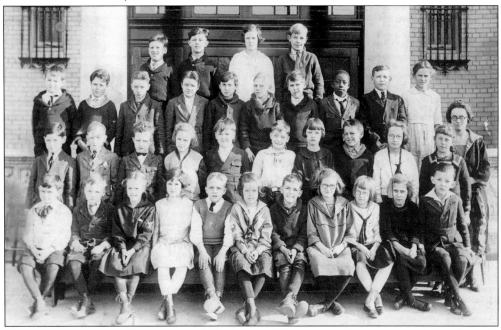

This picture was probably taken in 1922, the year Washington School opened. Fourth-grade teacher Miss Huntzberger stands at right. The day the school opened, Principal Elsie Emerick led the students from the Ammann Avenue School down Washington Road to the new school. She carried a Bible in one hand and a flag in the other.

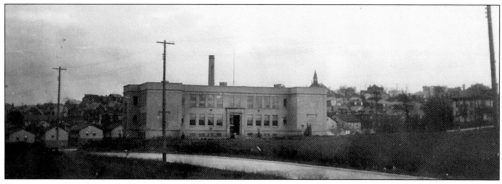

Constructed at the corner of Beverly Road and Ralson Place, Lincoln Elementary School opened in 1925. It was the second school built in the burgeoning school district. That same year, a gas station opened on Beverly Road—the first business in what would become a popular shopping district.

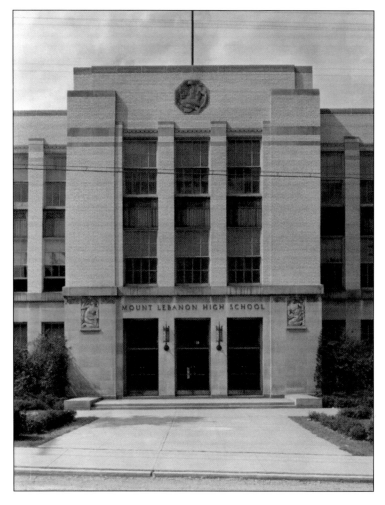

Mt. Lebanon High School opened its doors to grades 7 through 9 in the fall of 1930 and to grades 10 through 12 in the fall of 1931. It was the school district's fifth building, following Washington, Lincoln, Howe (1927), and Markham (1929) Elementary Schools. (Courtesy Brady Stewart Studios.)

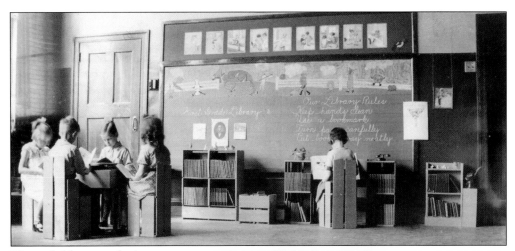

These children are playing library at Lincoln Elementary School in the spring of 1935. "We made this 'library' out of orange crates from a grocery store on Beverly Road," said Bertha Abbott Thomas. The chalkboard announces "First Grade Library" and lists rules to follow. The students are, from left to right, Peggy Schanke, Jim Rohrich, Richard Bird, Bertha Abbott, and Peggy Morrow. (Courtesy Bertha Abbott Thomas.)

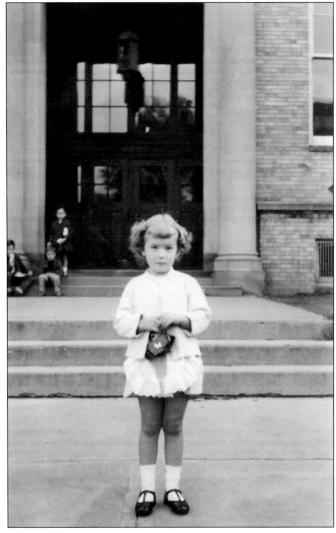

Like many little girls before and after her, Jeanné Heid dressed up for her first day of kindergarten. This photograph was taken in September 1949 in front of Lincoln School. (Courtesy Jeanné Heid Bereznicki.)

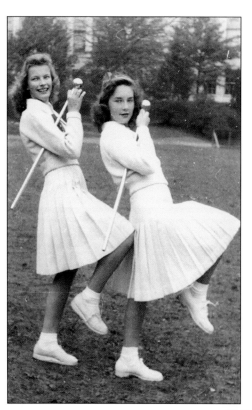

Majorettes Marjorie Hoff (left) and Gladdy Lou Miller practice their moves in 1941. Gladdy Lou would later become the high school band's head majorette from 1943 to 1945.

The caption accompanying this picture from the 1943 Mt. *Lebanon Log* reads: "Bill, Peggyjo, and Roger in a lighter moment." (Courtesy Mt. Lebanon High School.)

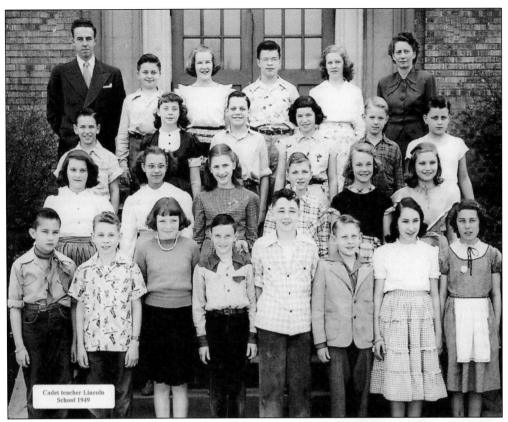

Cadet teacher Lincoln
School 1949

Above, Eugene Holmes Shaffer (standing at left in the back row) was Mt. Lebanon's first male elementary-school teacher. He began his long career with the school district in 1949 as a cadet teacher. Over the next 32 years, Shaffer would teach at Lincoln and Jefferson Elementary Schools, Jefferson Junior High, and the high school before joining the administrative ranks in 1965. He created the logo that the school district used for many years and launched the district's communications program, which included *The View*, a monthly newsletter published in cooperation with the municipality between 1969 and 1981 (it later became *Mt. Lebanon* magazine). When *The View* debuted, Mt. Lebanon Marching Band members delivered it to homes (right). (Above, courtesy Sue Caspari.)

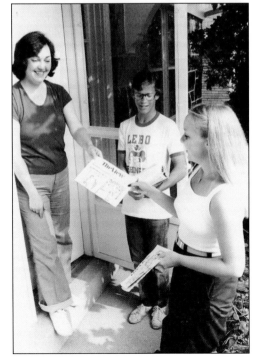

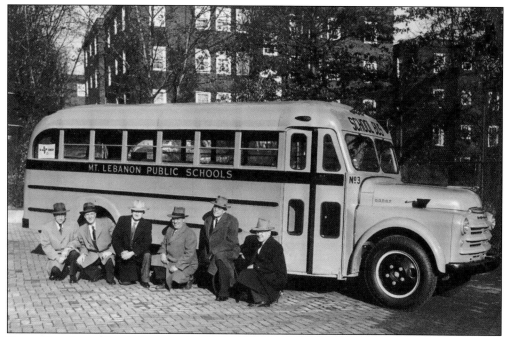

Pictured in this undated photograph taken for the *Pittsburgh Sun-Telegraph* are superintendent of schools Ralph Horsman (far left) and school board president A.C. McMillan (second from right). This may have been the school district's first bus. The apartments of Central Square can be seen in the background. (Courtesy Jean McMillan.)

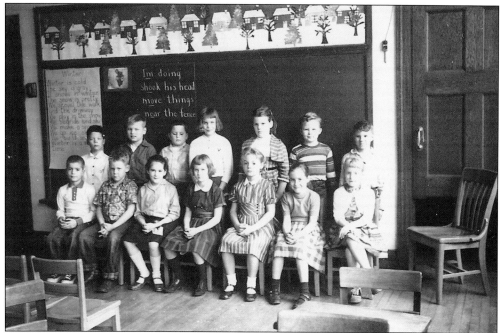

This picture shows one of Eleanor McClelland's classes and what a typical Mt. Lebanon classroom—including chalkboard, wooden floors, and chairs—looked like in the mid-1950s. McClelland taught at Washington Elementary School from 1938 to 1977.

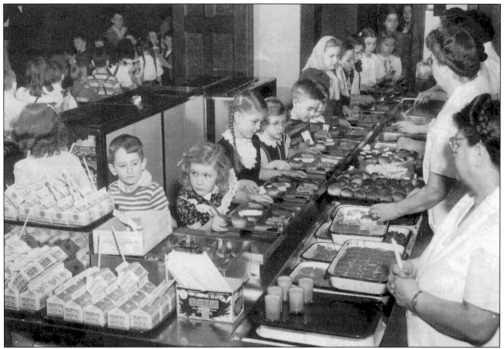

St. Bernard's Catholic School opened in 1925. By 1954, student enrollment had grown to the point that an addition was needed. In this c. 1955 photograph, children make their way through the lunchroom, although they don't seem very happy about the selection. (Courtesy Dave and Julie Davis.)

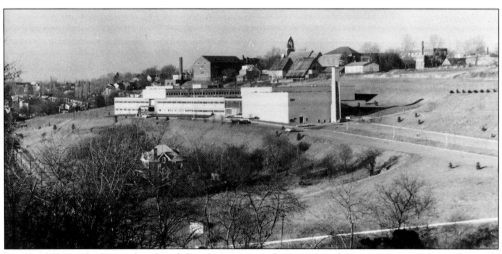

South Hills Catholic High School, located at Mt. Lebanon's northeastern tip on McNeilly Road, opened in 1956 as a boys' school. In 1979, it merged with the all-girls Elizabeth Seton High School to become the coed Seton–La Salle Catholic High School. Pictured in the background are the DePaul School for Hearing & Speech, which was built in 1911 and relocated to Shadyside in 2002, and the Toner Institute and Seraphic Home for Boys, which opened a Mt. Lebanon location in 1914 and closed in 1977.

Students perform a class play at Washington Elementary School about 1960.

In 1963, Hoover Elementary on Robb Hollow Road became the seventh elementary school—and last school—built in the community.

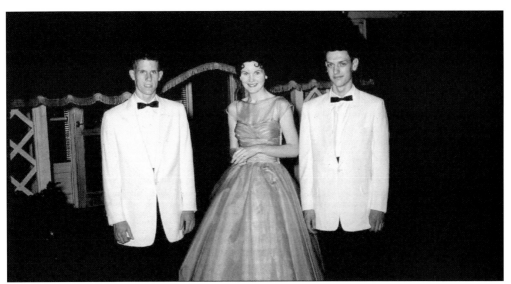

Phil Mathewson (left), Kathleen Allen, and Dave Royer pose for a picture at Mt. Lebanon High School's 1959 class prom. (Courtesy Phil Mathewson.)

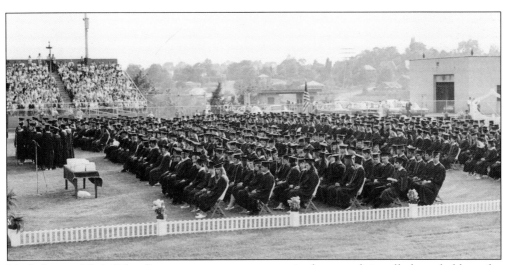

Mt. Lebanon High School's commencement ceremonies have traditionally been held on the school's football field. Here, the 1969 graduating class prepares to receive their diplomas. (Courtesy Fake Lebo.)

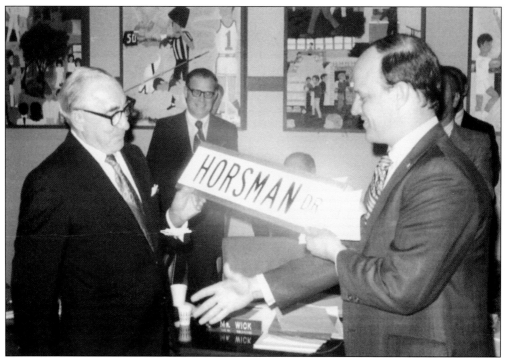

Dr. Ralph Horsman (left) came to Mt. Lebanon as a math teacher in 1929 and went on to serve as an elementary, junior high, and high school principal and assistant superintendent before becoming the school district's superintendent in 1946. When he retired in 1969, the street around the high school was named for him.

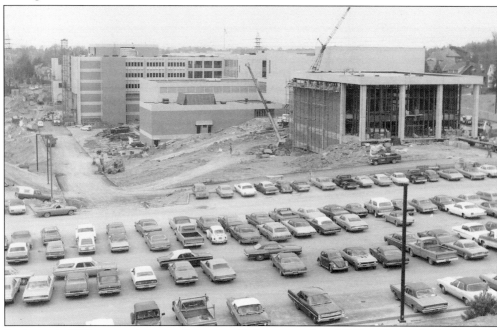

In the early 1970s, as student enrollment swelled to more than 8,700 students, the high school underwent an expansion that included a fine arts wing, pictured at right.

Four

SPORTS AND RECREATION

Mt. Lebanon schools are known for their outstanding sports teams and the community for its superior recreation facilities. But these boys, playing near Cedar Boulevard's Wildcat Field around 1944, prove having fun is the best sport. The boys pictured here, from left to right, are as follows: (first row) Jerry Tyroflat, unidentified, Gordon Sutton, and four unidentified boys; (second row) Frank McGinnis, Harry Marsh, Vince Albo, Tom Mallen, and Jim Steen; (third row) Ted Ranch and Wayne Komara. (Courtesy James Steen.)

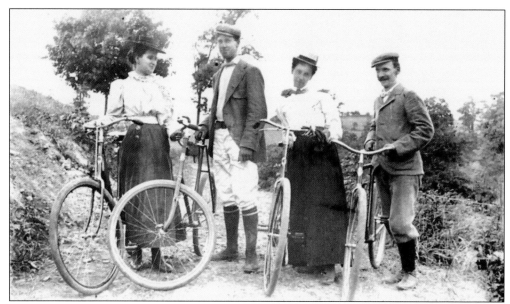

In the 1890s, before automobiles became the preferred method of transportation, a bicycle fad swept the nation, and, it appears, Mt. Lebanon. Posing near the corner of Washington Road and Alfred Street with their bicycles are, from left to right, Mrs. Furen, J. Guy Smith, Mrs. Hower, and Dallas D. Hughey.

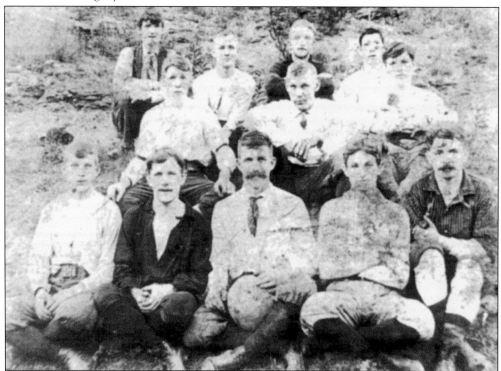

John Hallam (seated center with ball) formed the first Beadling soccer team in 1898. It was an outlet for the coal miners, many of whom had come from European countries with soccer traditions. It was such a beloved game that coal miners who played received preferred treatment in the mines.

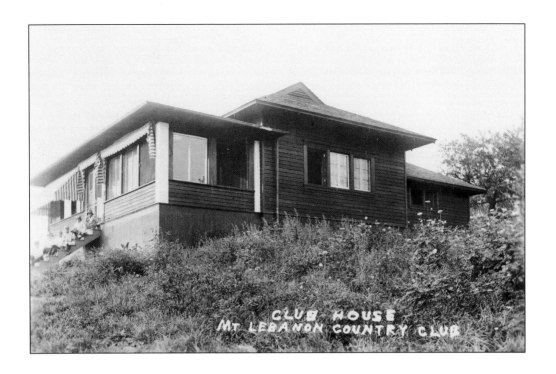

In 1912, the Mt. Lebanon Country Club, located along Bower Hill Road between Kenmont and Coolidge Avenues, offered a nine-hole golf course, clubhouse (above), and tennis courts (below). Dr. Ed Saeger, a club caddie, recalled in a 1982 *Mt. Lebanon* magazine article that, "anybody who was anybody belonged." The club closed in 1918, two years after St. Clair Country Club was founded. The clubhouse eventually became a private residence that still stands, although it has been moved to another location.

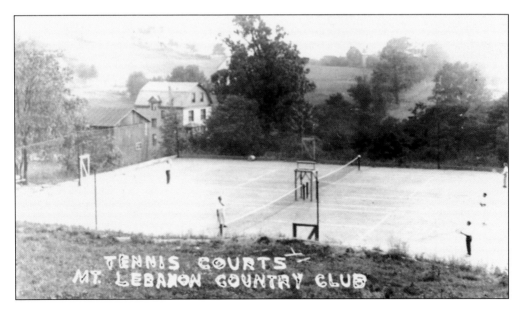

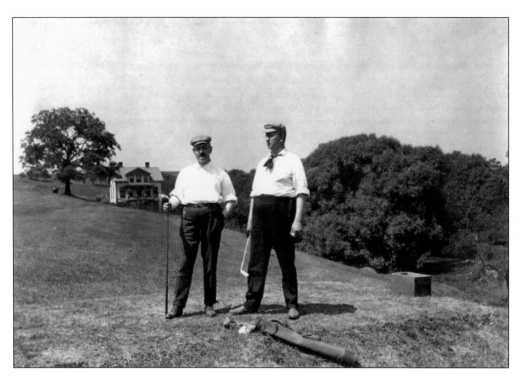

The unidentified—but very dapper—men pictured above enjoyed a round of golf about 1914 at the Castle Shannon Country Club. It became the Mt. Lebanon Golf Course in 1947. The old clubhouse (below) no longer exists. The first golf game on the course was played on July 4, 1907, after Joseph Howard Cochrane and Joseph Permar asked their neighbor Nancy Smith if they could use part of her farm to try the new game. Cows served as moving hazards. (Above, courtesy Peg and George Smith; below, courtesy Paul Dudjak.)

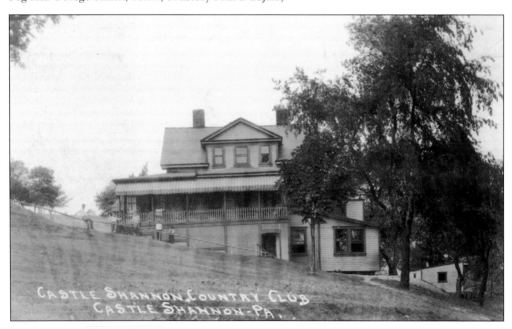

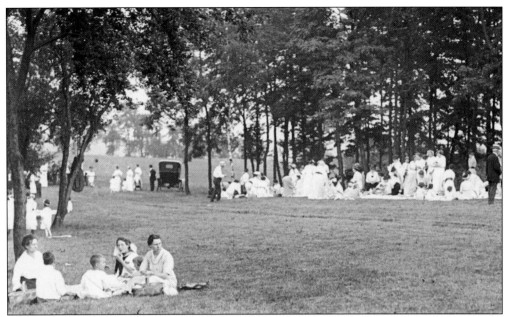

In the late 1800s and early 1900s, Mt. Lebanon Cemetery was used for gatherings, including an undated church picnic (above) and a 1923 church baseball game (below). In a 1983 *Mt. Lebanon* magazine interview, 75-year-old Edward Alderson said, "We had Sunday school picnics in the flat area behind Mt. Lebanon Cemetery. We played ball and pitched horseshoes. Everyone brought their lunch, sat around, and shot the bull." Baseball was a popular sport at the time, and an April 17, 1909, *South Hills News* article reported, "The Mt. Lebanon A.C. will open baseball season May 1 on the home grounds at McKnight Park, opposite the UP church . . . the grounds will be improved with a small grandstand for the accommodation of ladies and children." The exact location of this field is unknown, but the McKnights did own land across Washington Road from the church.

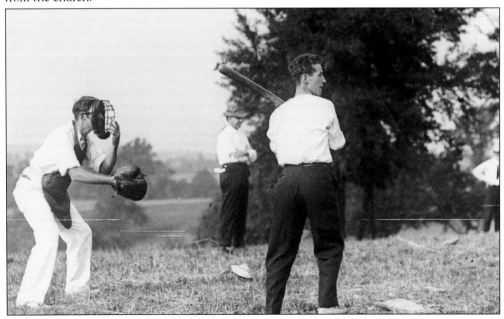

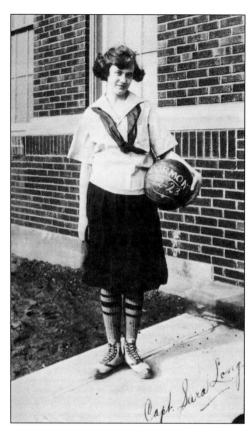

In 1922, Sara Long Lewis Ewalt was captain of the high school's girls' basketball team. At the time, Mt. Lebanon did not yet have a high school, so local students attended Dormont High School—hence "Dormont" on the ball.

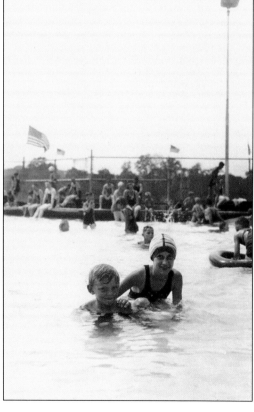

Unidentified children swim in the old Mt. Lebanon pool in the 1930s. Mt. Lebanon's first pool was built in the 1930s as a Works Progress Administration project. In the 1950s and 1960s, the second level of the pool's changing rooms featured "the Rec," a hangout for high school kids that had refreshments, pool tables, Ping-Pong, and a record player. (Courtesy Joy Pajak.)

Victor "Okay" Doak (second from left in the back row) was a history teacher who coached in Mt. Lebanon for 42 years. Mt. Lebanon High School's tennis team was the first sports team to attain a championship. The tennis singles champs pose in their tennis whites in this photograph from the 1930s.

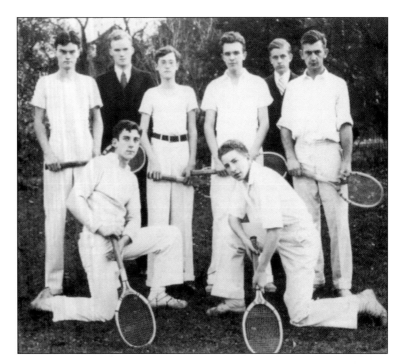

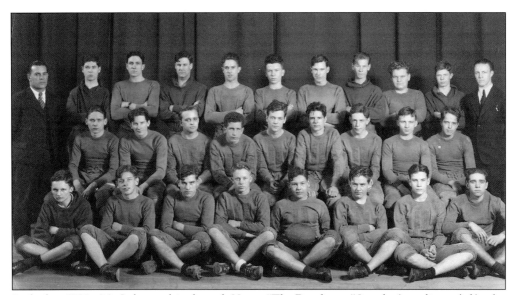

In the late 1920s, Mt. Lebanon hired coach Henry "The Dutchman" Luecht (standing at left), who would, over the next 25 years, establish Mt. Lebanon's football dynasty. In 1946, he became the head coach at Washington & Jefferson College. Pictured in this 1930 photograph are Jay Wells (second row, fourth from left), who lettered in football, basketball, wrestling, and track and Bill "All-Everything" Davidson (third row, fifth from left).

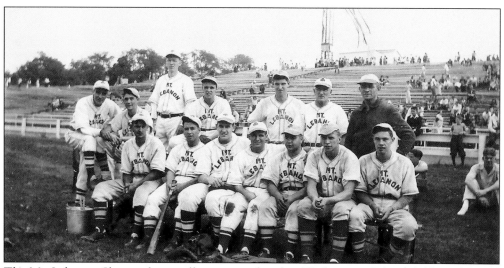

The Mt. Lebanon Shamrocks, a college team, played at Washington School field until World War II. Pictured at a 1940 Labor Day game in South Park are, from left to right, (first row) Henny Ackerman, Jim Kennedy, Bill McMinn, unidentified, Tony Valicenti, Bob Frank, and Jim Eckenrode; (second row) unidentified, George Smith, Ray Jones, Bill Buttlar, unidentified, manager George Geisinger, and sponsor Mr. Frank.

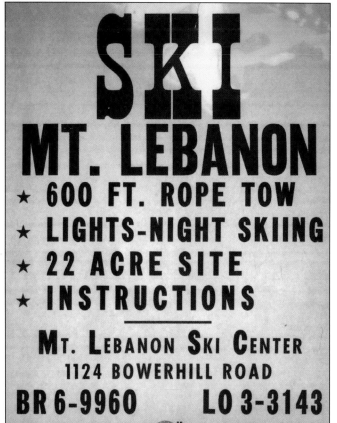

SKI MT. LEBANON

★ 600 FT. ROPE TOW
★ LIGHTS-NIGHT SKIING
★ 22 ACRE SITE
★ INSTRUCTIONS

MT. LEBANON SKI CENTER
1124 BOWERHILL ROAD
BR 6-9960 LO 3-3143

For three seasons, beginning in 1961, the Mt. Lebanon Ski Center operated on Bower Hill Road, where the Bower Hill Apartments now stand. Bud Stevenson, who ran the ski slope, relied on naturally occurring snow because Scott Township residents objected to the potential noise that could be created by artificial snowmaking equipment.

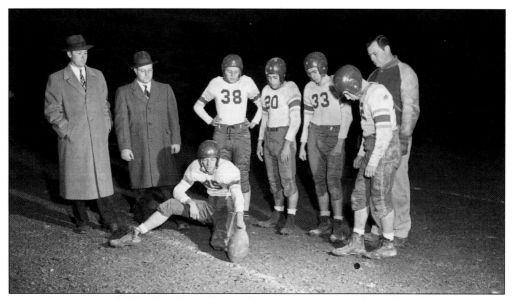

Two fathers and coach "Big" Jim Daniell (at right in the varsity jacket) watch as the Mt. Lebanon Wildcats practice in 1947. (Courtesy Brady Stewart Studios.)

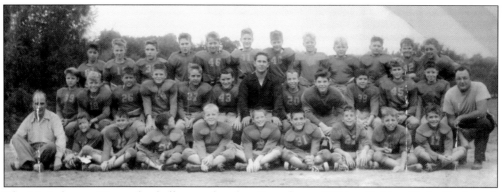

The Mt. Lebanon Kittens football team played on Saturdays at Wildcat Field on Cedar Boulevard. Players could not weigh more than 100 pounds, says Glenn Barton, who, in this 1951 picture, stands fourth from the left in the third row. To the far left in the first row is Coach Schroeder, and Coach Yeckley is at right. (Courtesy Glenn Barton.)

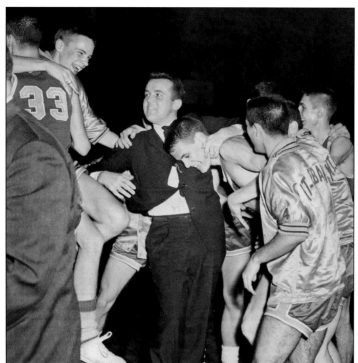

In 1961, coach Dick Black (center) made history when he led the Mt. Lebanon Blue Devils to a Western Pennsylvania Interscholastic Athletic League (WPIAL) championship win, advancing the team to the semifinals of the Pennsylvania Interscholastic Athletic Association (PIAA) tournament. It was the school's most successful basketball season.

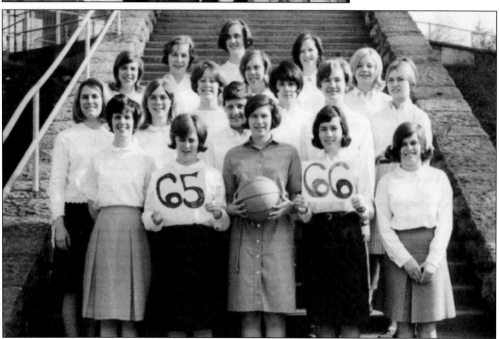

The 1965–1966 Mt. Lebanon Girls Varsity Basketball team under coach Pat Hutcheson were, from left to right, (first row) Marty Morris, Chris Mager, Sue Witt, Mari Doren, and Marcia Jones; (second row) Linda Crow, Sue Zook, Jane Barnes, Nan Roberts, and Judy Fidler; (third row) Tina Bauman, Helen Hindmarsh, Linda Young, Sharon Hudson, and Kit Dapprich; (fourth row) Mary Cathey and Marty Schreiner; (fifth row) Barb Schneider. (Courtesy Mt. Lebanon High School.)

In 1966, the Mt. Lebanon High School football team earned its first WPIAL championship title. Celebrating here are, from left to right, Vince Russo, Steve Foster, Gary Sawhill, coach Ralph Fife, Jack Mathison, and Vic Surma. (Courtesy Glenn Barton.)

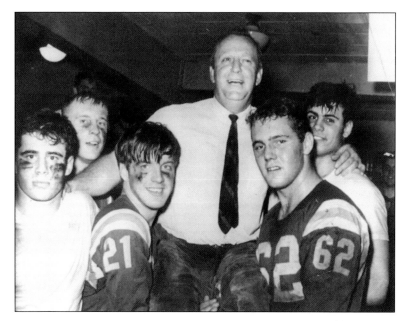

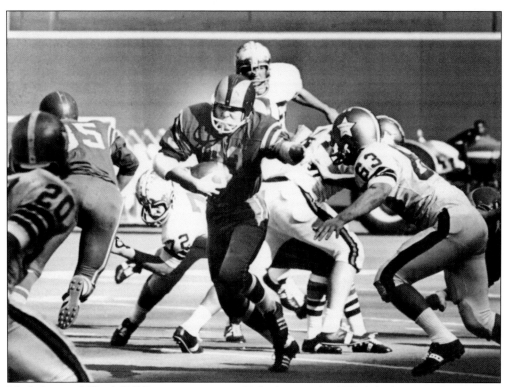

Mt. Lebanon fullback Bill Dunn runs against Kiski Area in the 1970 AA championship game at Three Rivers Stadium—the WPIAL's first game at the new venue. (Courtesy Jeff Linkowski.)

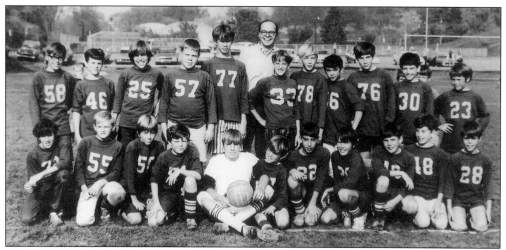

In 1970, George Kesel (back row, center) organized the Mt. Lebanon Soccer Association, with 24 boys in grades four to seven (under-14 age group). Kesel and Rod Agar coached this team. Agar organized the girls' league in 1975, the first such program in western Pennsylvania. Subsequently, the association promoted the high school varsity teams: boys in 1973 and girls in 1979. (Courtesy George Kesel and the Mt. Lebanon Soccer Association.)

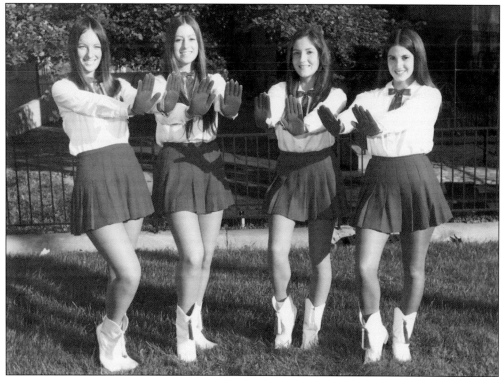

What would a sporting event be without someone to cheer on the team? Mt. Lebanon has a long tradition of cheerleaders, majorettes, Blue Devils, color guard, and Rockettes who help to keep the teams motivated. In Mt. Lebanon, many girls dream of being Rockettes. Band director Phillip Prutzman created the Range Rockettes in 1953, modeling the drill team after the University of Texas's Rangerettes. This picture of four Rockettes was taken around 1970.

Five

BUSINESSES

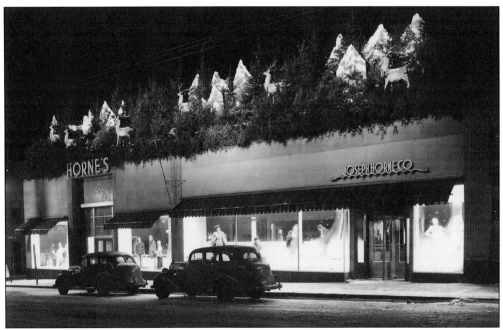

On May 8, 1945, the Joseph Horne Company moved into the former Boggs and Buhl building at the corner of Washington Road and Central Square. (That Boggs and Buhl, which opened on September 11, 1940, was Pittsburgh's first suburban department store.) Horne's later expanded, adding a housewares department in the strip mall across the street. Horne's closed soon after South Hills Village opened in 1965. (Courtesy Nellie Ambrose.)

Alderson's Five Mile House on Washington Road at the top of Cochran Road was probably one of the first businesses in the area that would become Mt. Lebanon. So named because it was five miles from the city, the stagecoach inn opened around 1835 and closed in 1878. The building was destroyed by a fire in 1927, and a Lutheran church was constructed in the area in 1954. (Sketch by Kensey Clarkson.)

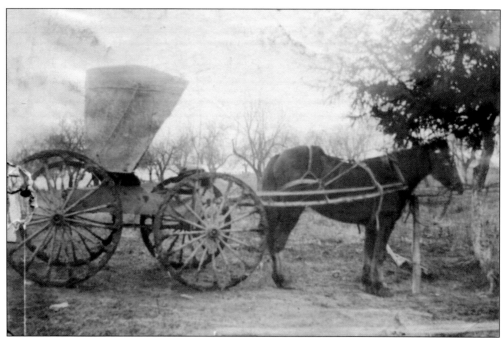

Among Bryson Schreiner's papers was this picture labeled "The Doctor's Aid, Thanksgiving Day 1894." This was probably "Old Doc" Schreiner's buggy that took him on calls all over the South Hills. He charged $2 for a house call and $10 to deliver a baby. An old *Liberty Ledger* article said the doctor's "horse and buggy never adorned the hitching posts of the saloons between Pittsburgh and Mt. Lebanon."

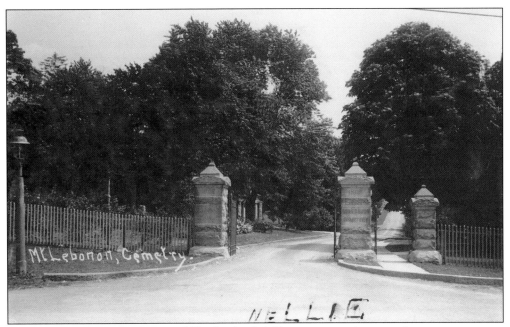

Nursery owner Henry Bockstoce sold his land to local businessmen who wanted to start a cemetery. Although it opened with a grand gala on June 25, 1874, the corporation soon failed and was sold at a sheriff's sale in 1880. It reopened under new management in 1899. (Courtesy Evie Reece.)

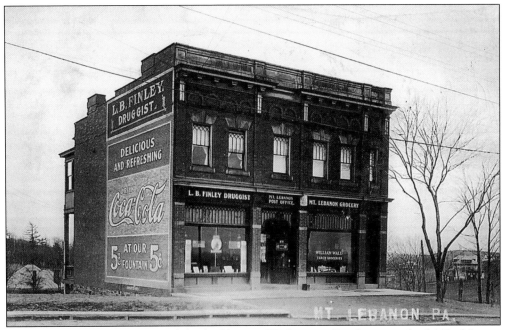

Pharmacist William Lowe erected this building on Washington Road, just north of Alfred Street. It was one of the first commercial buildings in what would become Mt. Lebanon's central business district. Lowe and grocer John Taylor conducted business here until 1909, when they sold the building to pharmacist/postmaster L.B. Finley and grocer William Wall. This picture was taken about 1915.

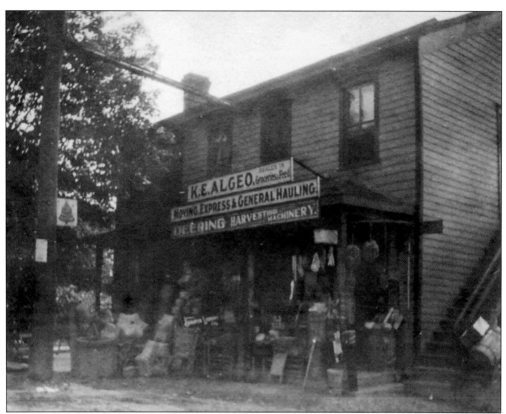

Park and Kate Algeo purchased a store (above) on the corner of Washington and Bower Hill Roads in 1898. "What a treat it was to go to Algeo's!" wrote Ferne Horne in a 1962 memoir. " 'Everything under the sun' might have been the store's motto, for it contained everything from farm supplies of all kinds to a pack of needles. Harnesses and hams hung from the ceiling, blankets, notions, meat, cheese, tools, feed, cement, yard goods—one could have spent an entire week just peering at all the merchandise." In 1903, the community's first telephone exchange—LOCUST—was installed on the second floor. The operators used the outside staircase on the right side of the building to get to the phone. Below is a picture of Algeo's delivery wagon in 1916.

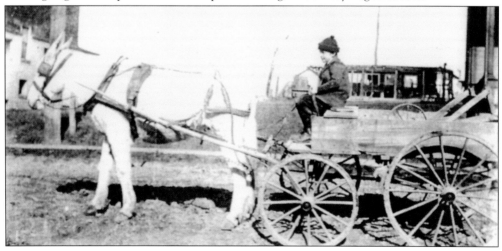

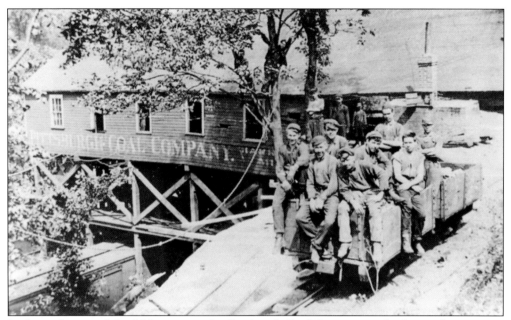

In the early part of the 20th century, the Pittsburgh Coal Company and other coal companies owned much of the land in what are now the Cedarhurst and Beadling areas. Haul ways and galleries of mines underlie portions of the municipality, including parts of Beverly Heights, Mission Hills, and Sunset Hills. When coal was being extracted, Mt. Lebanon residents aboveground could feel the mining explosions that were happening 40 to 50 feet below the surface. The above photograph was taken at the coal tipple near Robb Hollow Road. Pittsburgh Coal Company created Cedar Lake (below) as a coal-washing facility, but by 1930, the coal company had completed its operations and began selling the land to developers.

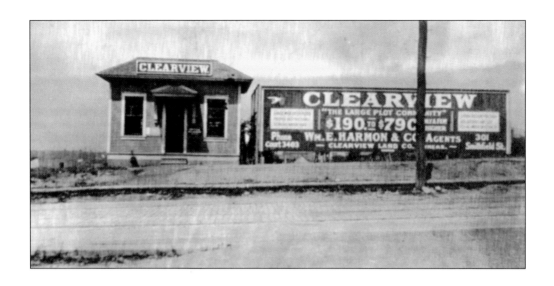

The sales building for the Clearview Plan (above) sold lots for Justus Mulert's Clearview subdivision, so named because it offered an escape from the smoky city. The company was started in 1902, and this picture was taken in 1916. The Ellison building (below), which replaced the sales building at the corner of Cedar Boulevard, would itself be replaced by the Cyclops Building in 1966.

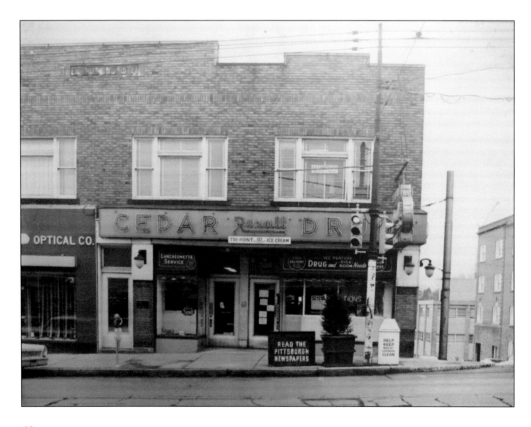

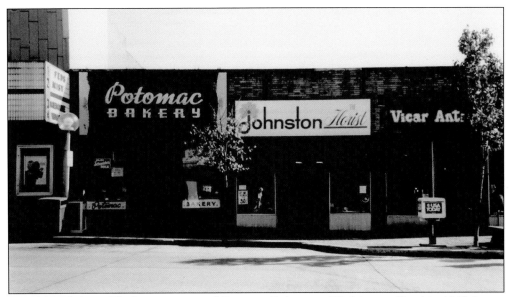

Wendel and Anna Fleckenstein opened Potomac Bakery on Washington Road in 1949. It was their second store, the first having opened on Dormont's Potomac Avenue in 1927. (Courtesy Lillian Tate.)

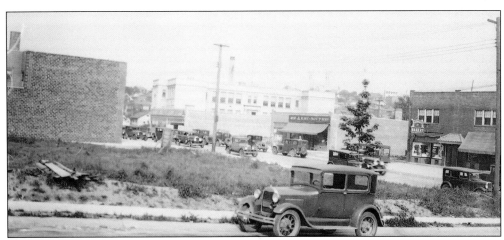

The Beverly Road shopping district began in 1925 with a gasoline service station and quickly grew. Over the years, it would include bakeries, groceries, pharmacies, jewelry stores, gift shops, and ice cream parlors.

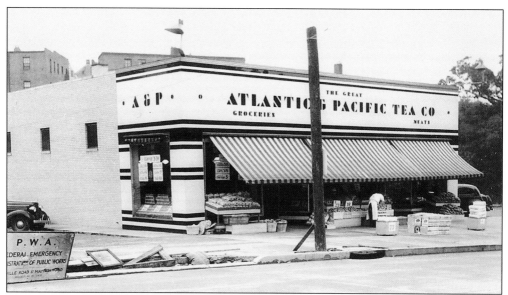

This photograph shows the A&P market on McFarland Road in the 1930s. Around World War II, the grocery moved to a larger building farther down the road, and a Donahoe's market moved into this spot. In 1953, Rollier's hardware, which originally opened in 1922 in Shadyside, took over the building. It was the first local self-serve hardware store with prepackaged nuts, bolts, and nails. Pictured below are, from left to right, Doug, Bob, and Chuck Satterfield—sons of H. Doyle Satterfield and Alice Rollier—who joined the business in 1966. Ten years later, they transformed the 10,000-square-foot yellow-brick building with a new barn façade. In 1994, they moved the store to Washington Road. (Below, photograph by Bill Metzger.)

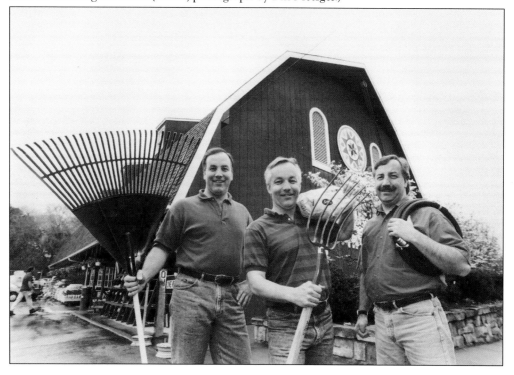

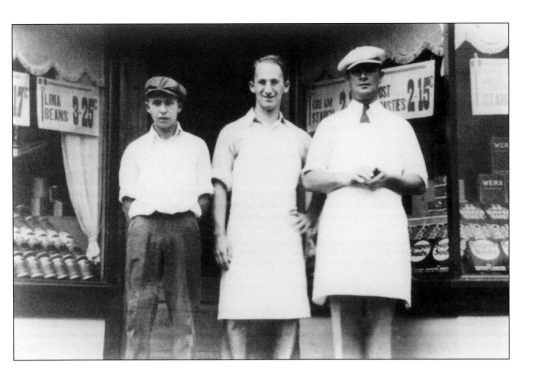

Above, Ewart Kirsopp (right) stands outside his Gilkeson Road store with stock/delivery boy Dan Lacey (left) and employee Raymond Smith. Kirsopp opened the store in 1921, and it served many of the Polish, Italian, and German immigrants who worked in the Beadling mines. Below is a c. 1935 photograph of Kirsopp's Market. The store was razed in 1962. (Both, courtesy Eleanora Kirsopp Mays Freas.)

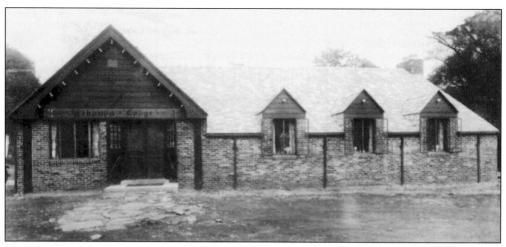

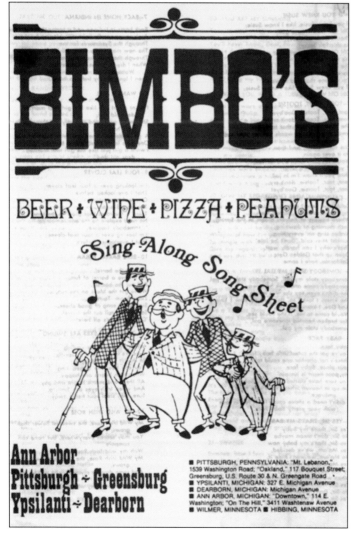

John Simmonds built the chalet-style Lebanon Lodge in 1932 and operated it with his wife, Katherine, the daughter of Park and Katie Algeo. The lodge was a popular spot for the high school's in crowd. After the business closed in 1945, the building housed a smorgasbord restaurant and then a furniture store. In 1971, it became Bimbo's, a pizza joint that was a popular destination for birthday parties, which concluded with a pie in the face of the birthday boy or girl.

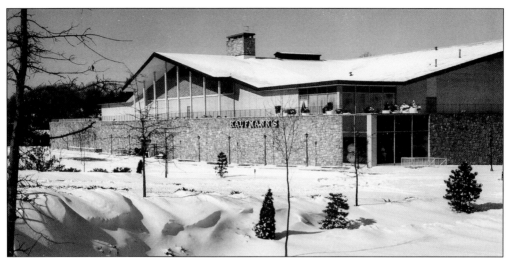

Kaufmann's Department Store opened on August 3, 1963, at the corner of Washington and Gilkeson Roads, complete with beauty salon and the Tic-Toc restaurant. The property had formerly been occupied by Romeo's Nursery. Kaufmann's moved to South Hills Village Mall in 1987; the Galleria moved into the vacant Kaufmann's building in March 1989.

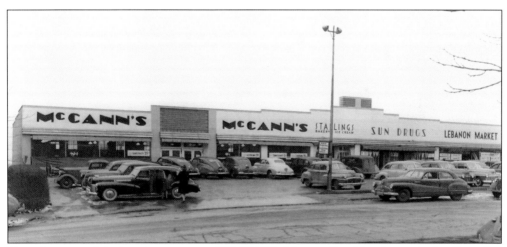

Over the years, this shopping center at 712–724 Washington Road has housed a bowling alley (below the McCann's store), an arts center, a Sun Drugs, and a teen center called the Outside Inn. Not visible in this 1947 picture was a Bard's ice cream/delicatessen at far right. The Washington Square Condominiums were built behind the shopping center in 1981.

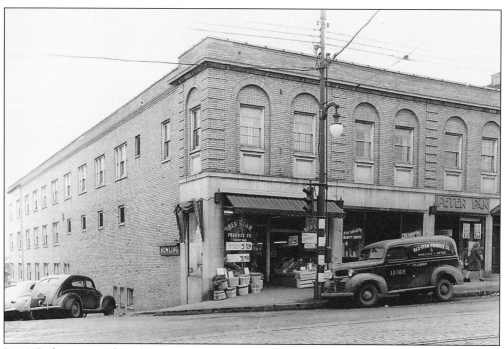

In 1947, the corner of Washington Road at Cedar Boulevard was home to Red Star Market and a bowling alley.

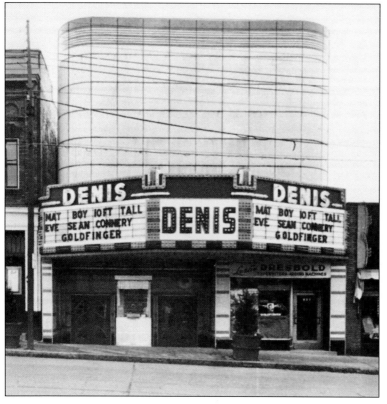

Denis Harris opened the Denis Theater in 1938 (the original marquee included the name "Harris"). The one-screen theater had seating for 1,200. This picture was taken in 1964, one year before the second Denis Encore theater was added. In 1981, the main theater was divided into three screening rooms.

Haller's used-car lot was located on Washington Road across from the Hallers' home and automobile dealership. From 1919 to 1959, the Haller family helped Mt. Lebanon residents meet their automobile needs.

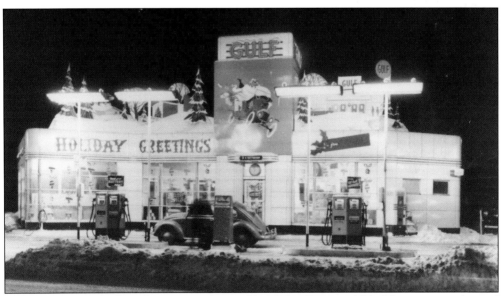

This Gulf station, built in the 1940s and owned by Wilber Raymond "Pat" Paterson, was located at the corner of Cedar and Cochran Roads. Every year, Gulf Oil would host a Christmas contest for the best decorated station in the tristate area. In 1957, this Gulf station took first place. The gas station was razed in 1964. (Courtesy Glen Barton.)

Mike's Pizza, which shared a storefront with St. Clair Lounge on Bower Hill Road, is said to have been the first pizza shop in Mt. Lebanon.

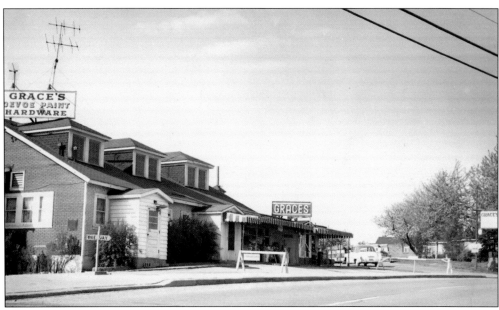

In the 1940s, Dorrance and Grace Hobbes took over Bower Hill Road's Oasis nightclub and renamed it Grace's, a hardware/general store that sold everything from shoelaces and six-packs to barbecue sandwiches and ice cream. In 1973, the Hobbes' son-in-law Elmer Hill took over the store and remodeled it. This picture was taken in May 1967.

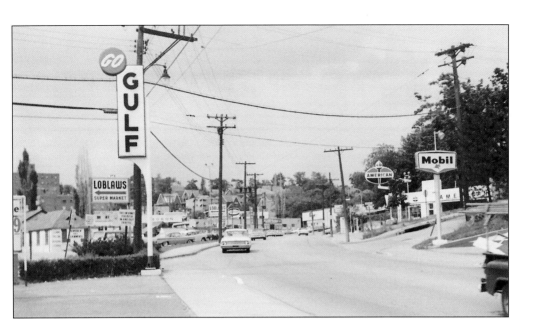

Cochran Road, pictured above in 1964 looking toward Bower Hill from near Academy Avenue, seems to be little more than a row of gas stations. A closer look, however, reveals Loblaws grocery and, farther along at the intersection of Altoona Place, a Kroger's. Pictured below is The Buttery, a local diner located at the corner of Cedar and Cochran Roads.

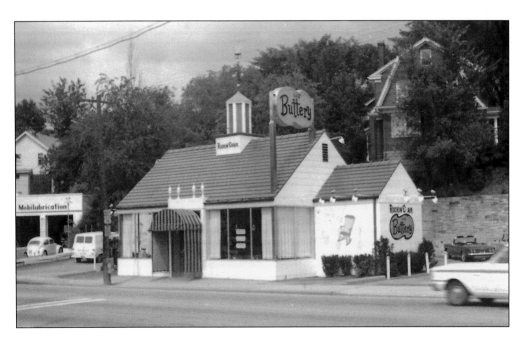

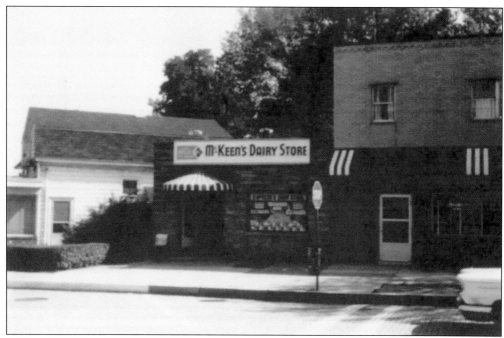

In the 1970s, one could get groceries at McKeen's Dairy Store on Castle Shannon Boulevard. The store also featured a counter where customers could enjoy an ice cream sundae. Out of frame and to the right was a corner bar. (Courtesy Dave and Julie Davis.)

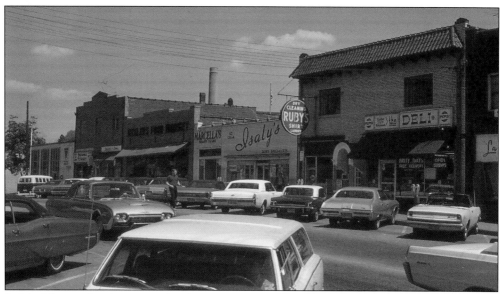

Isaly's deli was the place to go for skyscraper cones, Klondike bars, and chipped ham. In 1932, Isaly's opened a store at 313 Beverly Road. The store moved to 303 Beverly Road (pictured) in 1941 and closed in 1980. From 1931 to 1980, there was an Isaly's at 700 Washington Road, and from 1975 to 1980 there was an Isaly's in the St. Clair Shops.

Six

MUNICIPAL GOVERNMENT, CHURCHES, AND ORGANIZATIONS

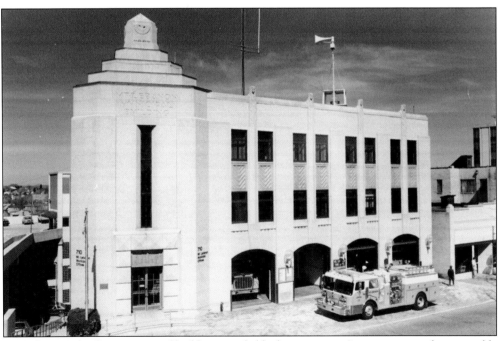

Mt. Lebanon's Art Deco municipal building is probably the community's most iconic and recognizable structure. Designed in 1928 by Mt. Lebanon resident William H. King Jr., it is made of Indiana limestone with decorative carvings. The $240,000 building was dedicated in September 1930 and, for many years, was home to the library and fire and police departments. It still houses the municipality's administrative offices. (Photograph by Bill Metzger.)

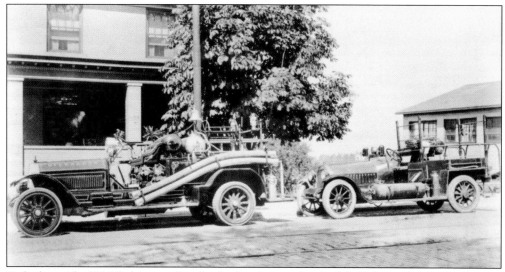

Parked outside 520 Washington Road, which is believed to be Mt. Lebanon's first fire station, are a 1923 American LaFrance 75 (left) and a 1918 Marmon 6 car that was converted into a fire truck. Mt. Lebanon's volunteer fire company was organized in September 1918. (Courtesy Mt. Lebanon Fire Department.)

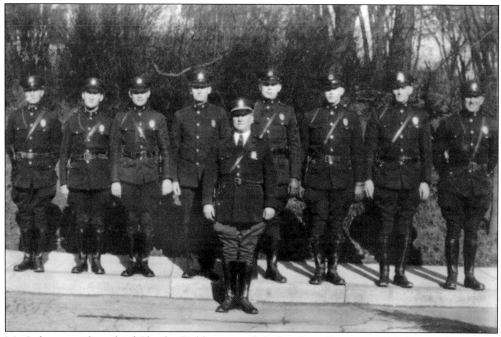

Mt. Lebanon police chief Charles Baldwin stands before his officers in 1928. Pictured are, from left to right, Robert Hasley, Ted Carrington, John Kauper, William Smith, Charles Senn (who later became chief), John Swoger, Edward Woods, and Arthur Siefert. Baldwin was appointed chief in July 1922 and, for a time, oversaw both the police and fire departments. (Courtesy Mt. Lebanon Police Department.)

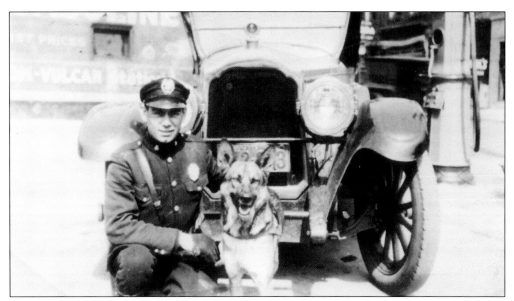

Mt. Lebanon police officer John Kauper and his dog pose outside the police garage on Washington Road, across from Alfred Street, in 1927. Kauper, who was hired in 1925 as one of the community's three police officers, rose through the ranks, becoming a captain in 1945. When he retired in 1966, his gifts included an electric coffee percolator, an electric waffle iron, and an electric clock. (Courtesy Mt. Lebanon Police Department.)

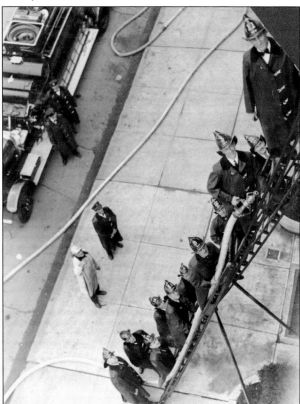

Mt. Lebanon firefighters conduct drills outside the Mt. Lebanon Municipal Building in the late 1930s. In the background is the department's 1932 Seagrave Suburbanite service truck. The fire department purchased both a Pirch and a Seagrave service truck in 1932 because their extra length could accommodate the ground ladders needed for apartment building calls. (Courtesy Mt. Lebanon Fire Department.)

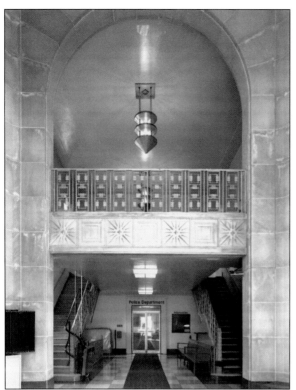

The inside of the Mt. Lebanon Municipal Building features Art Deco ornamental lighting fixtures, murals, wrought-iron window grills, terrazzo floors, and aluminum railings—in total, 1,400 pounds of aluminum were used for the building.

Mt. Lebanon's public works crew poses on Washington Road at Woodhaven Drive with the municipality's Elgin sweeper and truck around 1930. Standing in front of the truck are, from left to right, Charlie Long, Mike Danastasio, and Modesto "Desty" Ball. Tony Aston is seated in the back, and an unidentified man stands behind the flag. Another unidentified man and Clyde Falls (right) are standing in the truck.

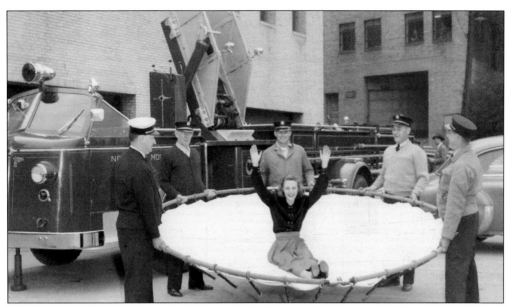

The municipal manager's secretary, Nancy Nordin, poses in May 1951 behind the municipal building. This picture was taken for a local newspaper to show off the department's new hydraulically operated, 100-foot, $33,500 ladder truck and 10-foot life net. Holding the life net are, from left to right, Chief Raymond Goettel, Lt. Joe Plante, driver James Woods Jr., Lt. William Housley, and Capt. Clyde Falk. (Courtesy Mt. Lebanon Fire Department.)

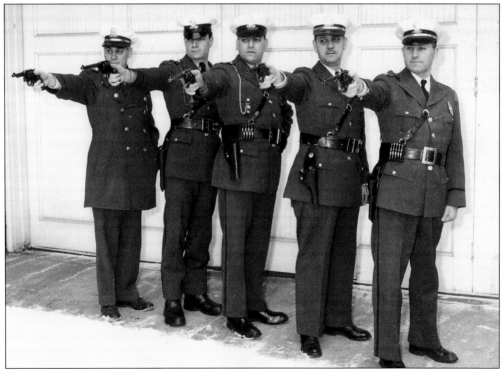

In this c. 1952 photograph, the Mt. Lebanon Police Department's pistol team takes aim. Chief Charles Senn created the team in 1940. (Courtesy Mt. Lebanon Police Department.)

Mt. Lebanon Public Library (shown above) opened on November 15, 1932, in the Mt. Lebanon Municipal Building. The original collection numbered 7,000 books—all donated by residents. Kathryn Peoples was the first librarian. When the library outgrew the space, architect J. Russell Bailey designed a 13,350-square-foot, $315,000 library (below) on Castle Shannon Boulevard. That library opened on January 27, 1964. In 1966, Betty Ann Stroup became library director; she served until 1988. Under Stroup's leadership, the library added a phonograph collection, a microfilm-based charging system, a copy machine, homebound services, and saw the installation of Joe Sevello's beloved murals of American folk heroes and clowns in the lower-level lobby and stairwell. By the 1990s, the library's collection had outgrown the space, and work began on a new facility designed by McCormick Associates architects. The new library opened on June 21, 1997.

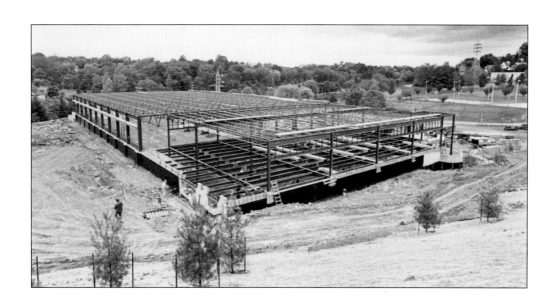

In the mid-1970s, work began on the Mt. Lebanon Recreation Center (above), which would include two ice rinks, meeting rooms, and an updated 50-meter outdoor pool (below). The project was completed in 1977.

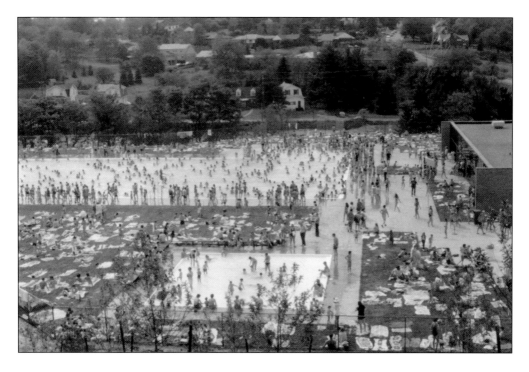

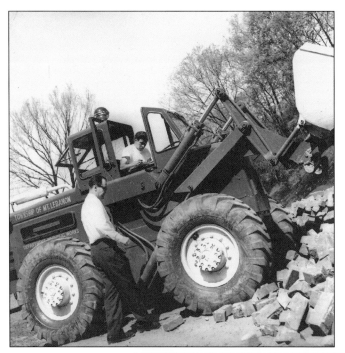

In this photograph from the late 1960s, an unidentified supervisor from the Mt. Lebanon Public Works Department watches as Tony Scarvace loads bricks needed for street repairs into a front-end loader. (Courtesy Mt. Lebanon Public Works Department.)

After years of debate about need and cost, the Mt. Lebanon Public Safety Center opened at 555 Washington Road on September 13, 2003. Police chief Tom Ogden (left) and fire chief Steve Darcangelo, with their respective staffs behind them, celebrate the opening of the new center. (Courtesy Mt. Lebanon magazine; photograph by Ed Rieker.)

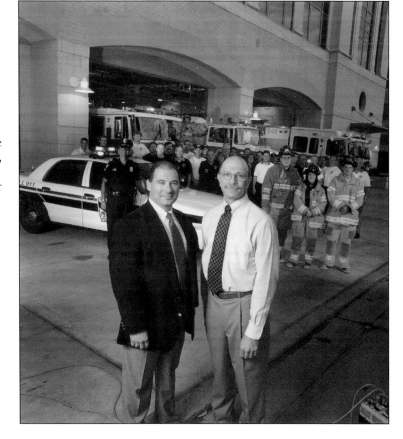

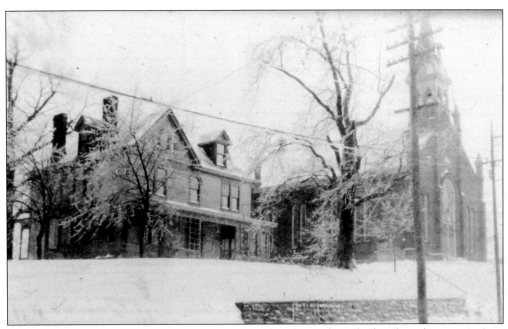

For many years, Mt. Lebanon United Presbyterian Church was the only church in the area. As Sara Long Lewis Ewalt wrote in a memoir, "Everyone living in Mt. Lebanon went to that church if they went to church at all." Founded in 1806 as the Associate Reformed Congregation of Saw Mill Run, the congregation has had three names and four churches. In the 1915 photograph above, the third church is to the right of the parsonage that stood on the corner of Scott and Washington Roads. The parsonage was built in 1905 for Rev. E.C. McCown. The fourth and current "Twin Towers" church was erected in 1929. This picture—probably taken in 1930—shows the two houses that served as parsonages on either side of the church. Both houses have been razed.

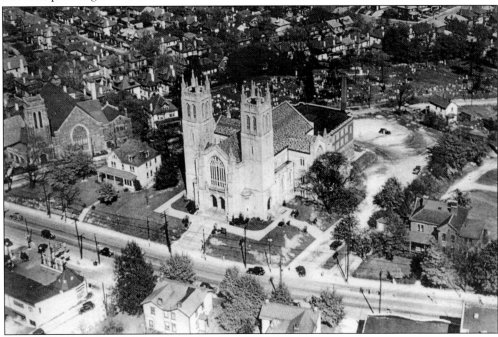

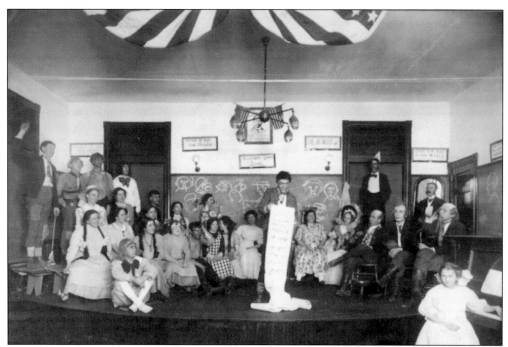

Before there was television, there was community theater. In the early 1900s, churches and schools would present plays, festivals, and pageants. In this picture, a group from what is now Mt. Lebanon United Presbyterian Church presents a play about school days. Mary Cort Schreiner, wife of township solicitor Samuel Schreiner, is in braids at left.

The imposing yellow-brick Baptist Homes house on Castle Shannon Boulevard was erected in 1915 to provide for orphans and the elderly. This picture was taken about 1935. The orphanage was phased out in 1972. (Courtesy Baptist Homes; photograph by Brady Stewart Studios.)

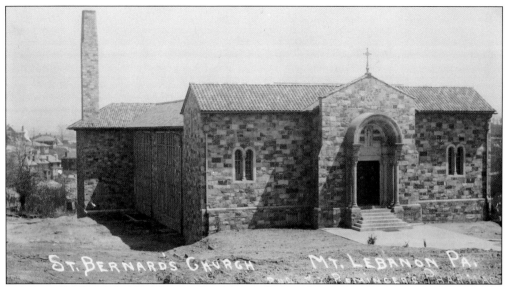

St. Bernard Church held its first mass in the Haller family's Washington Road carriage house on August 31, 1919. Later that year, the diocese purchased land on Washington Road and hired architect William Perry to design a church, school, and rectory. Construction took decades to complete, so temporary buildings, such as this one that was later replaced by the school, were erected and razed between 1920 and 1962, when the project was finally completed. (Courtesy Marian Wilson.)

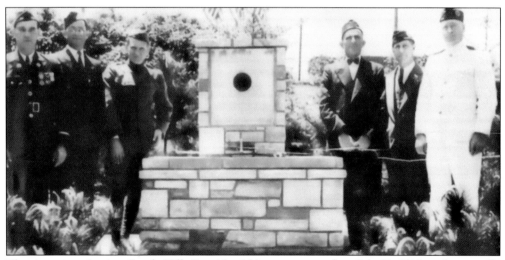

The American Legion South Hills Post No. 156 was organized on July 21, 1919, and originally headquartered in the Mt. Lebanon Municipal Building. The group participated in patriotic celebrations and gave out annual character award medals to local students. On May 31, 1935, they placed a drinking fountain in Dormont Park. Albert Schoenefeldt (second from right) was the owner of Dormont Concrete Company, which constructed the fountain.

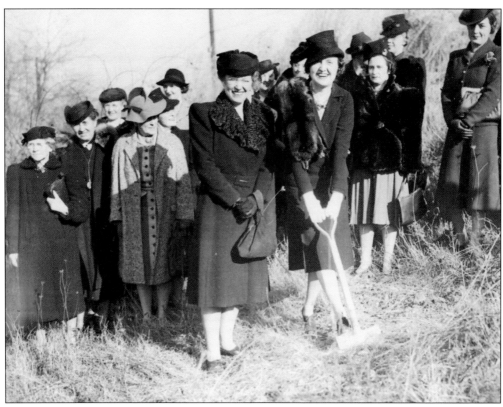

In 1924, a group of prominent local women founded the Mt. Lebanon Woman's Club to promote civic, educational, and philanthropic activities. For years, the group met in churches and schools. In 1940, the club held a ground breaking (above) for a clubhouse (below) on Hollycrest Drive that was designed by Ingham and Boyd architects. The club was an active force behind the creation of several local institutions, including the Mt. Lebanon Public Library. At its peak in the 1960s, the club had 1,400 members. The club was so prestigious that prospective members needed two sponsors to be accepted.

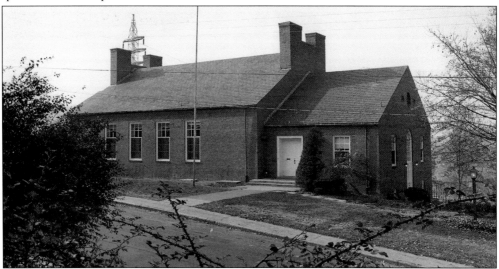

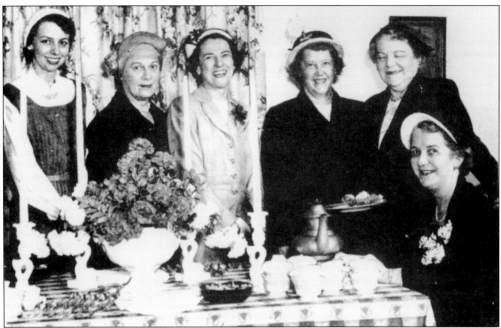

The Women's Fortnightly Review of Mt. Lebanon, formed in 1911, gave local women an opportunity to learn and serve. They studied social and political issues, endorsed women's suffrage, and made charitable donations or volunteered for causes related to those issues. The group was instrumental in starting Mt. Lebanon's first library and, in 1913, petitioned for the first garbage collection service. Here, members serve tea at a meeting around 1951.

The Mt. Lebanon PTA was formed in 1935 to enhance school buildings, enrich extracurricular programs, and oversee the safety of students. In this 1953 picture, the Washington Elementary School PTA executive board stands outside the school.

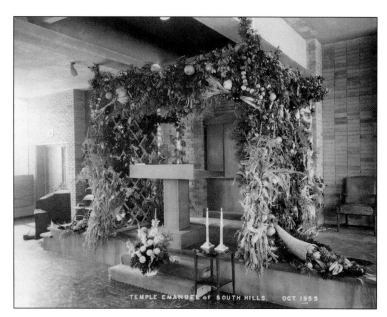

Mt. Lebanon's growing population of Reform Jews founded Temple Emanuel in 1951. For years, they used facilities around the community for services—including the gym at Howe School—until a building could be erected on Bower Hill Road. The first level (pictured) was completed in 1955 and the entire temple in 1962. (Courtesy Paula Altschul.)

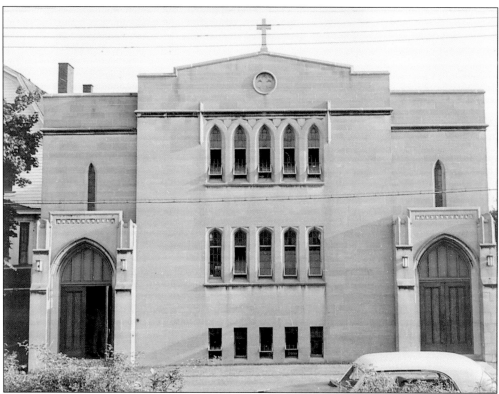

The only church in Mt. Lebanon that was razed and not rebuilt in the same location is this Lutheran church that stood on Academy Avenue. In 1954, after the Lutheran congregation moved down the street to its present location at the intersection of Cochran and Washington Roads, the Holy Cross Greek Orthodox Church congregation used the building until its own church was completed on Gilkeson Road in 1969.

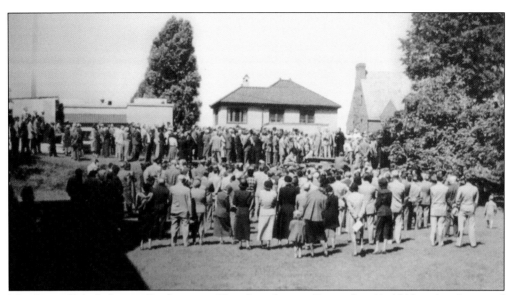

Members of Mt. Lebanon Presbyterian Church gather on September 11, 1949, to break ground for their new Christian education wing on Washington Road. The shadow from the church, designed by Pringles and Tufts architects, can be seen at left. The congregation changed its name to Southminster in 1965.

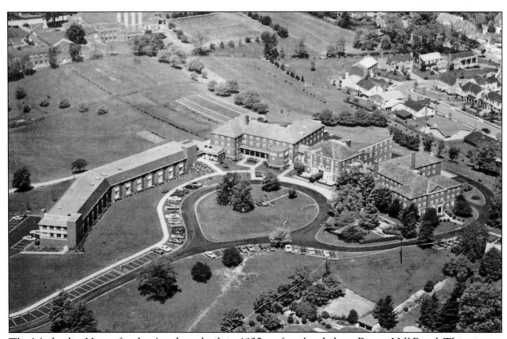

The Methodist Home for the Aged was built in 1925 on farmland along Bower Hill Road. This picture was taken in the early 1960s. The upper left corner shows the Bower Hill Community Church.

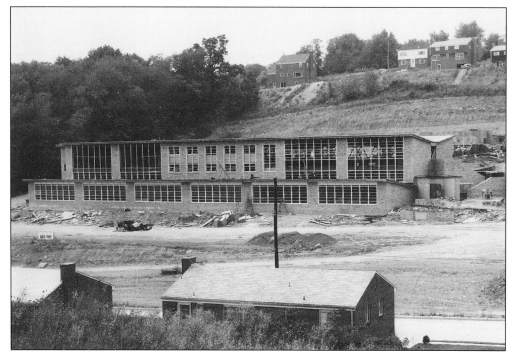

As Mt. Lebanon's Catholic population grew after World War II, the need for a second church became apparent. The diocese chose a spot near the Castle Shannon border, but the Mt. Lebanon Commission denied the permit. For about a year, the diocese and the municipality haggled over legal issues and zoning ordinances. The diocese won; St. Winifred School opened in 1962, and the church opened the following year. (Courtesy St. Winifred Church.)

St. Clair Cemetery on Scott Road was formed in 1806 for the members of the Associate Reformed Congregation of the South Hills. The third oldest cemetery in the South Hills, it is rumored to be the burial location of 10 Revolutionary War veterans, but only 3 have been identified. This picture was taken in the 1950s.

Seven

COMMUNITY AND EVENTS

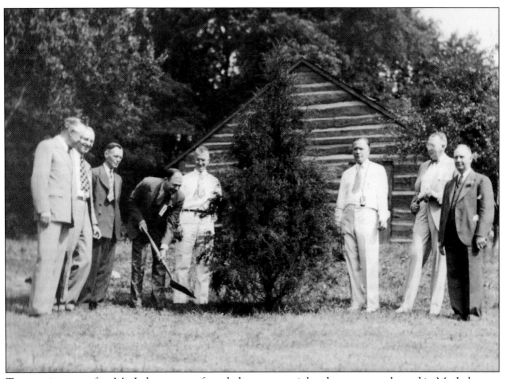

Twenty-six years after Mt. Lebanon was founded, a ceremonial cedar tree was planted in Mt. Lebanon Park. Pictured here are, from left to right, Rev. Edward McCown, Mt. Lebanon United Presbyterian Church; township solicitor S.A. Schreiner; township secretary F.W. Cook; commissioners R.L. Thompson and R.C. Giles; Dr. J.A. Basermen; T.R. Barr; and township manager A.W. Johns.

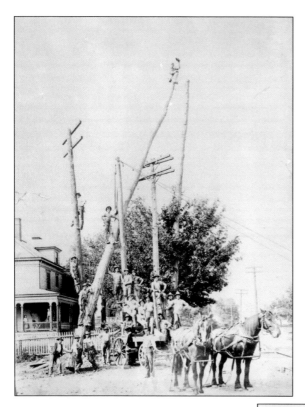

Telephone service reached Mt. Lebanon in 1903, when Algeo's store installed the community's first phone. In this picture, men install telephone poles along Washington Road at Bower Hill Road. Among those rumored to have the first residential phone lines were the Goodboys (at the cemetery gatehouse), the Hallers, and the Mulerts.

Silas Tomlinson, who posted this notice in 1907, owned approximately three acres on Washington Road, about where Southminster Church was later built. Farm sales like this would have been a community event where neighbors gathered to talk and share gossip. Tomlinson died in 1914 and was buried in Mt. Lebanon Cemetery.

PUBLIC SALE

The undersigned will offer at Public Sale at his residence on the Washington Road, one mile from Mt. Lebanon and one-fourth of a mile from Mt. Lebanon school, at 12 o'clock sharp,

FRIDAY, NOVEMBER 29, 1907,

the following property:

ONE GOOD MARE,

3 Wagons, 2 Cultivators, 1 double and 1 single Shovel Plow, a 2-horse plow, Harness of all kinds, Chains, Iron Kettles, Brass Kettle, lot of Brick, Stone, and Lumber, Hot-bed Sash.

HOUSEHOLD AND KITCHEN FURNITURE,

CARPETS, BEDDING, COMFORTS, CANNED FRUIT, JARS.

Also, one Stable and Shed, one Field of Corn in Shock, Stack of Hay, Berry Boxes, Chips, Bags and many other articles.

SALE POSITIVE, TO QUIT FARMING.

CHAS. E. SNEE, Auctioneer. SILAS TOMLINSON.

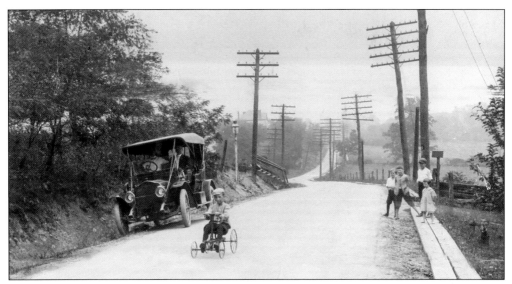

This picture ran in a May 1913 *Hilltop Record* newspaper with the caption, "Mt. Lebanon road, constructed of Warrenite. The surface is so smooth that even the children can enjoy themselves riding in their toy wagons, and the road is practically dustless." The picture was probably taken on Bower Hill Road, near present-day Meadowcroft Drive looking toward Washington Road.

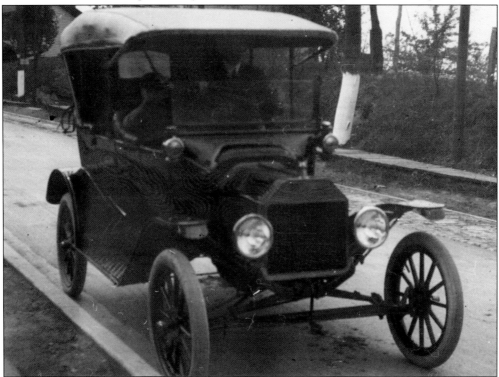

When Mt. Lebanon became a township in 1912, there were six cars in the community. This picture, taken in 1915, shows the first car of Dr. E.C. McCown, Mt. Lebanon United Presbyterian Church's pastor from 1904 to 1943. The car is parked outside the church on Washington Road, facing toward Dormont. The area in the background is where the Tuscany Apartments now stand.

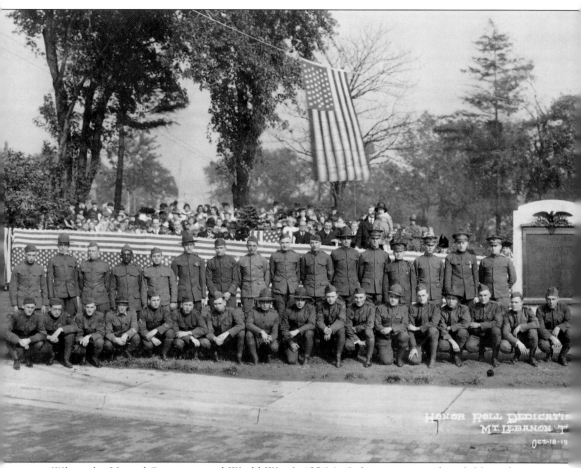

When the United States entered World War I, 135 Mt. Lebanon men enlisted. Upon leaving for service, each young man was presented with a money belt made by the local Red Cross unit, which operated out of the Ammann Avenue School. Eleven of these young men were wounded,

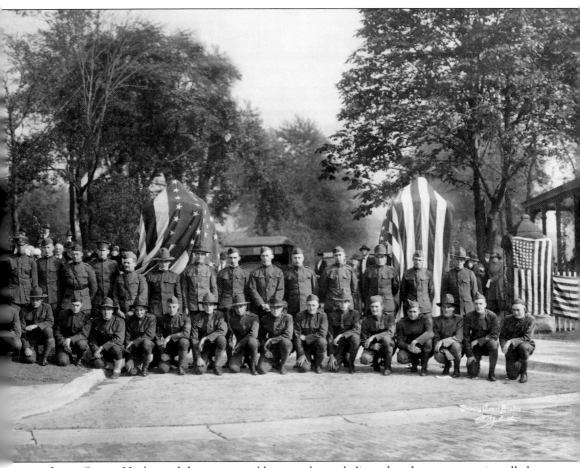

and one, George Hackney, did not return. Above, a plaque dedicated to those men was installed outside Mt. Lebanon Cemetery on October 18, 1919.

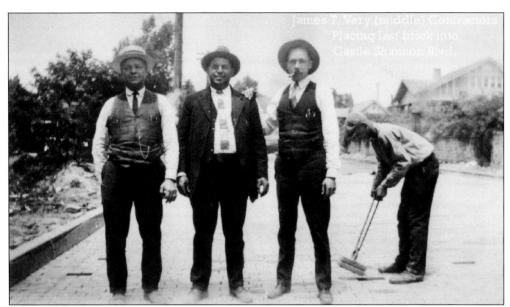

James T. Very Contractors celebrate as the last brick is placed in Castle Shannon Boulevard. Very is standing in the middle. The Bode house, located at the corner of Castle Shannon Boulevard and Sunset Drive, is in the background.

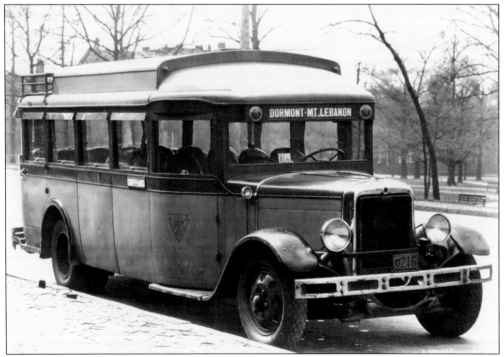

Pittsburgh Motor Coach Company started service to Mt. Lebanon about 1927. A March 1, 1932, *Pittsburgh Press* article reported that the company, which charged 25¢ per ride, objected to the competing Oriole Motor Coach Company's plans to lower its rates to 20¢. In the 1960s, four bus lines served Mt. Lebanon: Pittsburgh Railways, Oriole, Bigi, and Greyhound, the latter of which stopped at the Denis Theater.

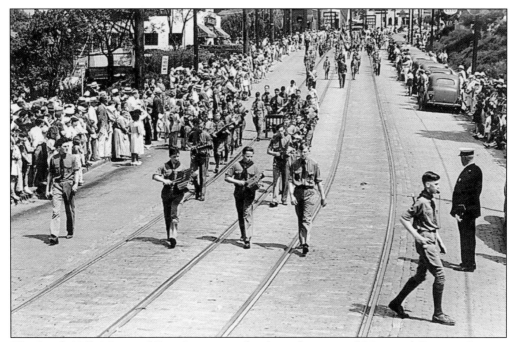

The South Hills Memorial Day Association has hosted an annual Memorial Day parade since 1934. In this picture, the Mt. Lebanon Boy Scout Troop (including twins Richard Pierce and Joseph Austin Duchene) heads down Washington Road, preparing to make the turn into Mt. Lebanon Cemetery. Pendale Nursery, now an apartment building, is the white structure at left. (Courtesy Jay Duchene.)

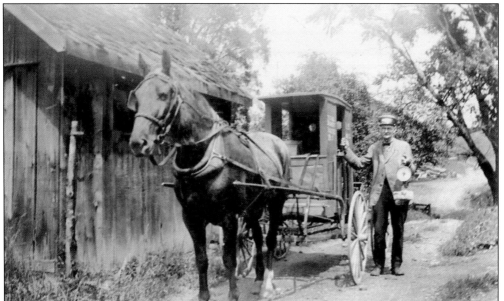

This c. 1935 photograph shows a Beadling mailman and his delivery wagon. Mail delivery to houses started about 1914—before then, if residents wanted their mail, they went to the local post office to pick it up. In 1928, city delivery arrived in Mt. Lebanon with a force of 31 mailmen and one rural carrier. (Courtesy Eleanora Kirsopp May Freas.)

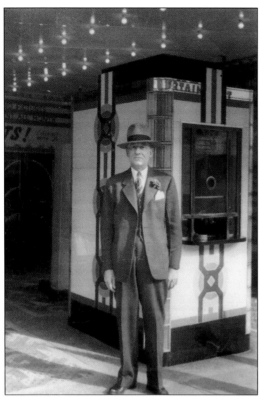

Les "Pop" Bowser poses by the Denis Theater's ticket booth on opening night, June 1, 1938. For many years, Bowser worked as a theater manager. The $250,000 building was designed by architect Victor Rigaumont in a functional moderne style and erected in 114 days. Sam DeFasio was the first manager. The *Pittsburgh Press* hailed the theater's air-conditioning system and the Carrara structural glass front that gave the theater "distinction." (Courtesy Alexander "Bud" Stevenson.)

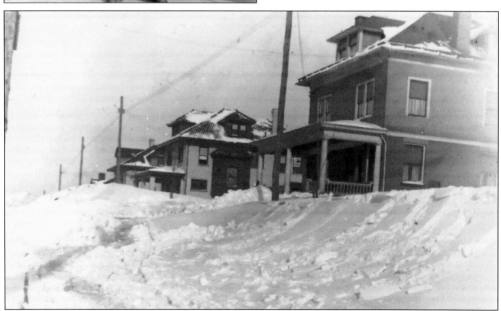

In November 1950, three storms converged and dumped a record 32 inches of snow on Pittsburgh. The snow started Thanksgiving afternoon and didn't stop until the following Tuesday, November 28. At the time, Mt. Lebanon had 50 miles of streets and only one pickup truck and two dump trucks, meaning many people were stranded in their homes until the municipality could rent six bulldozers from a Pittsburgh construction company.

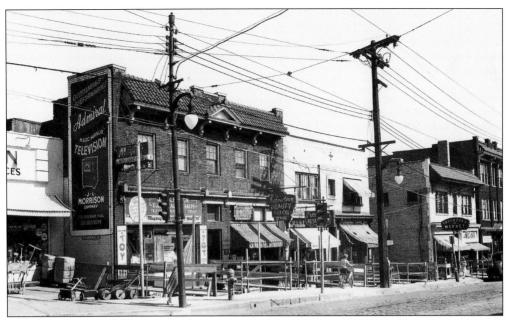

In 1950, a section of Washington Road between Alfred Street and Shady Drive East (pictured above) was widened at a cost of approximately $100,000. Five buildings on the east side of the street were rolled back 10 feet and 6 inches to clear a traffic bottleneck. The road was also widened in 1915. The December 21, 1950, photograph seen below was taken at the Washington Road reopening ceremony. Bobby Davison, son of commissioner W.B. Davison, cuts the ribbon while commission president Daniel Baker looks on. Capt. John Kauper and Sgt. Woolsey Meneilly keep the crowd in line.

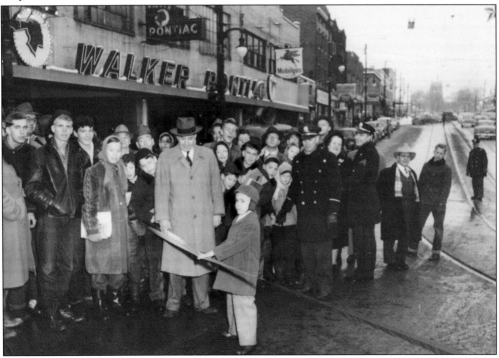

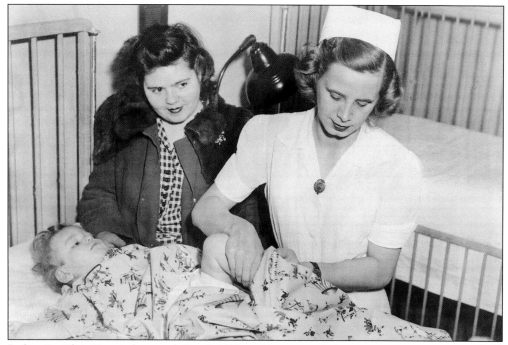

Before St. Clair Hospital opened, South Hills residents traveled across rivers to receive medical care. Dr. Arthur S. Haines led a campaign for a local hospital and the Silhol family donated land on Bower Hill Road. On February 22, 1954, the hospital opened, and Antonietta Daris (in bed) became the first patient. During its first year, the hospital admitted more than 4,500 patients and treated 8,500 emergency patients. (Courtesy St. Clair Hospital.)

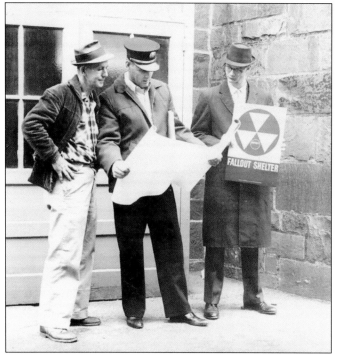

Reviewing a Cold War fallout shelter plan are, from left to right, William O'Mara, St. Bernard Church; firefighter James Wood; and Donald Simpson, Army Corps of Engineers. Believing fallout would take 20 minutes to reach Mt Lebanon from Pittsburgh, the 10-minute drill was instituted, in which children living within 10 minutes of the school would be sent home, and the remaining children would stay at school. (Courtesy Mt. Lebanon Fire Department.)

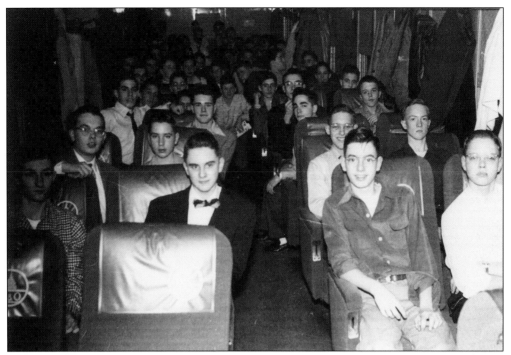

Members of the Mt. Lebanon High School Marching Blue Devils head to Dwight D. Eisenhower's inaugural parade in 1953. This was the band's first out-of-town trip, and it was undertaken with lightning speed: they traveled by train to Washington, DC, performed, and headed home within 36 hours. Notice that the boys traveled separately from the girls. (Courtesy Regis Englert.)

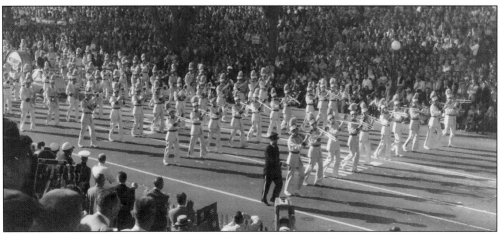

The Mt. Lebanon High School Marching Band performed at the Rose Parade in Pasadena, California, on New Year's Day 1959. (Courtesy Jeff Linkowski.)

For Mt. Lebanon's 50th anniversary in 1962, Nancy Coulter Langston (standing at far left) was crowned Mt. Lebanon's Jubilee Queen. The other young ladies in this photograph were honored with a title and a place in the court.

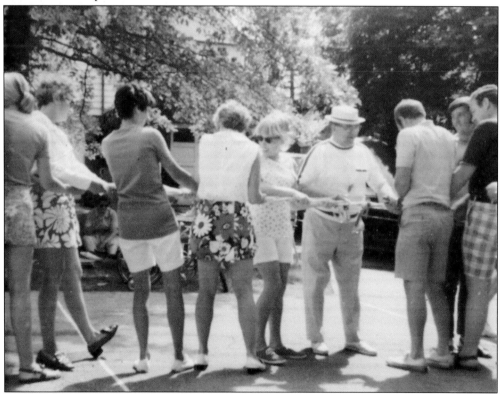

Block parties are one of the things that make Mt. Lebanon such a great place to grow up. Many neighborhoods, such as Westover Road, have block party traditions that date back decades. Carol Cready and Mr. Sneeden, who are both facing the camera, prepare for a men versus women tug-of-war on July 4, 1969. (Courtesy Gwyn Cready.)

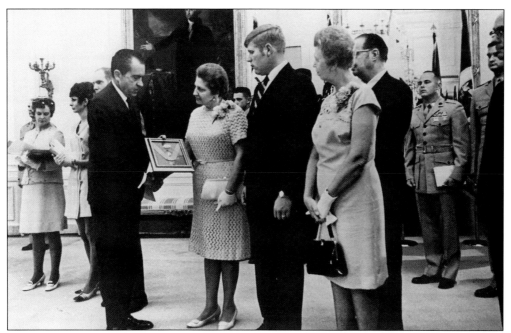

In 1970, Pres. Richard M. Nixon presented the Morgan family with the Medal of Honor in recognition of their son Bill Morgan's actions in February 1969, which saved two members of his Marine Corps squad but took his life. Morgan was one of 11 Mt. Lebanon residents who died while serving in Vietnam.

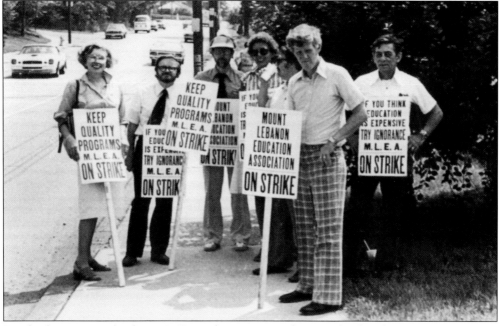

For the first time in the district's 67-year history, Mt. Lebanon schoolteachers went on strike on September 4, 1979. The strike lasted six weeks. Standing on Cochran Road outside the high school are, from left to right, teachers Martha Martinez, Ron Charlton, Tom Stacey, Ann Funk, Richard Strobel, Hugh Carr, and Tom Taylor.

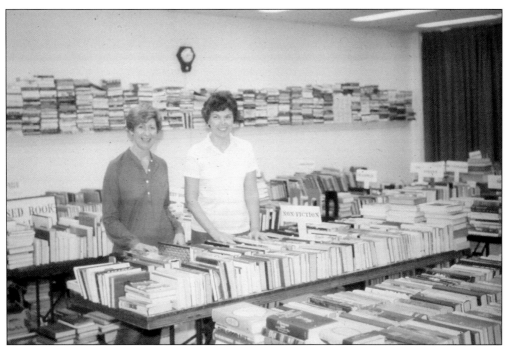

In 1968, the Friends of Mt. Lebanon Library started an annual used-book sale fundraiser. Phyllis Moore, pictured at right with volunteer Beryl Powell, chaired the event from 1978 to 1999, overseeing a corps of volunteers who would organize thousands of books into a tiny meeting room. Over the years, the book sale, which eventually became a bookstore, has raised more than $500,000 for the library.

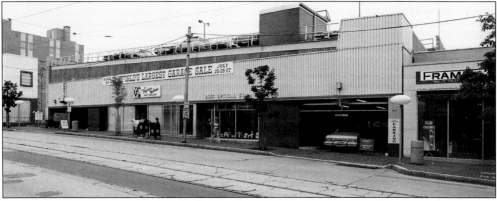

The World's Largest Garage Sale, which started in 1974, was a summer tradition. For three days in July, the North Garage would close to cars and open to antique dealers and flea market vendors. Built in 1958, it was Pittsburgh's first suburban parking garage. It was razed in the 1990s, and although a new garage was built, the garage sale was never reinstituted. (Photograph by Bill Metzger.)

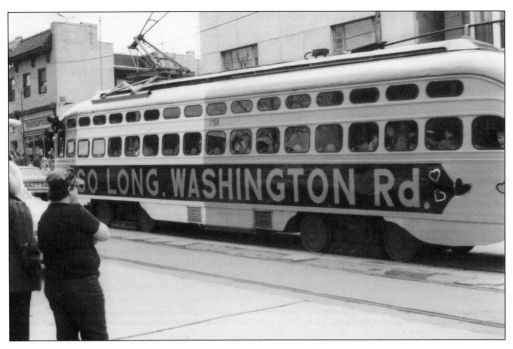

After serving Mt. Lebanon for 83 years, the last trolley (above) traveled Washington Road on April 14, 1984. In recognition of the event, the community held a Trolley Day celebration. Shortly thereafter, the trolley tracks, wires, and concrete safety dividers were removed from Washington Road, and work began for the new light-rail station on Shady Drive East. A 1986 picture (below) shows work on the station platform and tunnel. Several houses and an apartment building were razed for the project. (Above, courtesy Nancy J. Krauth Fenton.)

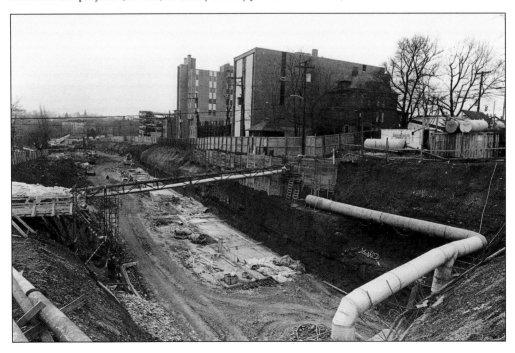

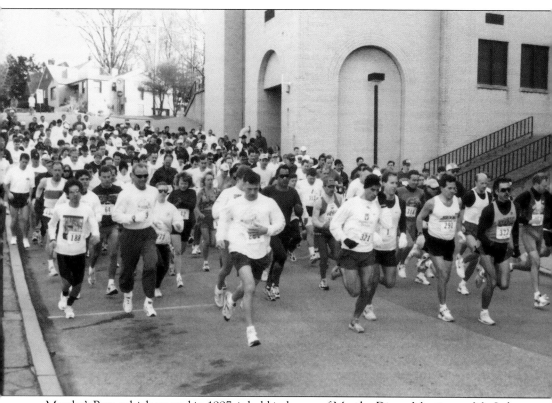

Martha's Run, which started in 1997, is held in honor of Martha Dixon Martinez, a Mt. Lebanon High School alumna and FBI special agent who was killed in the line of duty in 1994. The run raises money to improve area parks. (Courtesy *Mt. Lebanon* magazine; photograph by C.J. Betzler.)

Eight

SCENES

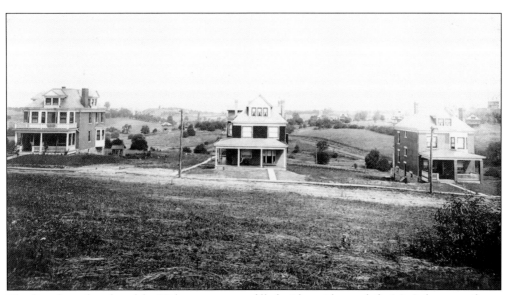

The first three decades of the 20th century were filled with rapid growth for Mt. Lebanon as farms gave way to suburban houses. A total of 440 applications were submitted for building permits in 1928. This picture of houses on Lebanon Avenue captures what would have been a familiar sight at the time: pastures giving way to backyards.

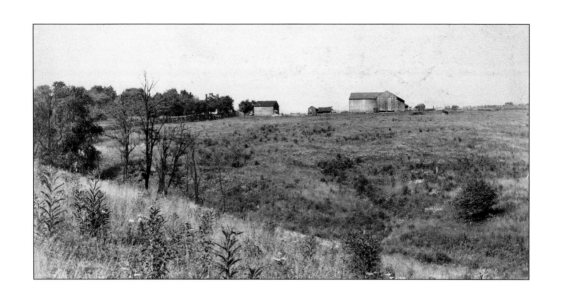

The first permanent settlers—Alexander Long, Andrew McFarland, John Henry, and William Lea—arrived in South Hills in the late 1770s and established farms. By 1900, about when these pictures were taken, Mt. Lebanon was still predominantly farmland. Around 1850, James Irwin established a farm (above) near the areas now known as Sunset Drive and Catalpa Place. Five generations of Irwins and Martins lived there until the farm was sold in 1922 to make way for the Sunset Hills development.

This picture of the watering trough on McFarland Road, just west of Beverly Road, was taken around 1900. George Phillips's farm can be seen in the distance at left. Before cars and tunnels, it was a two-hour trip from Beverly Road to Pittsburgh.

The Phillips family owned a farm in the area of present-day Theodan Drive. This picture was taken in 1912.

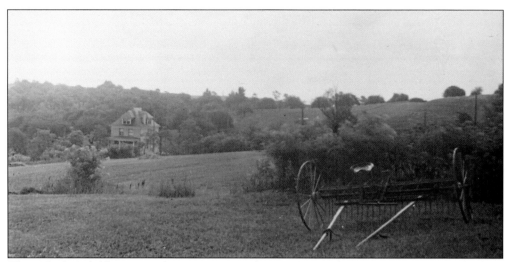

This is Bailey's field in 1912. This picture was taken on Annapolis Avenue in Dormont, looking toward McFarland Road and what would become the Parker Gardens development, named for developer William J. Parker.

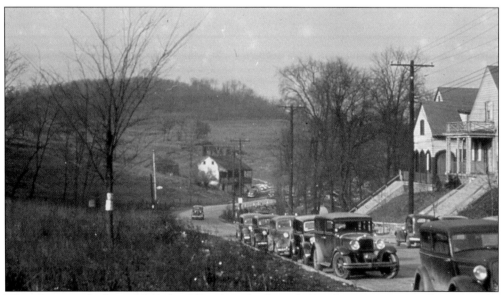

This photograph shows McFarland Road at the Beverly Road intersection in the 1920s. At one time, the hill approaching West Liberty Avenue was so steep that bus drivers had to ask passengers to disembark so the bus could make it to the top. The Bailey family, who owned the property adjoining McFarland Road, gave land to the township so that a bend could be installed to ease passage.

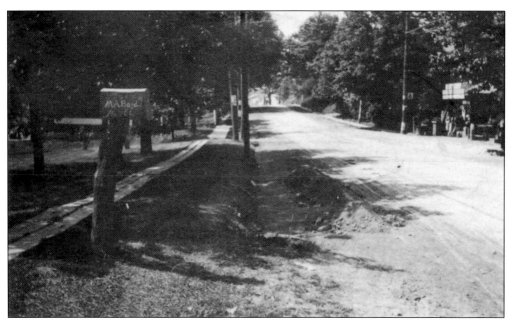

"Mt. Lebanon's Busy Street," which was written on this picture postcard, was obviously a joke, but years later, this bucolic dirt road would become the community's busiest thoroughfare. This picture was taken around 1905 outside Reverend Boyd's house, the Mt. Lebanon United Presbyterian Church parsonage, looking south down Washington Road. Algeo's store can be seen at right. "M.A. Boyd" on the mailbox was the reverend's widow; she died in 1923.

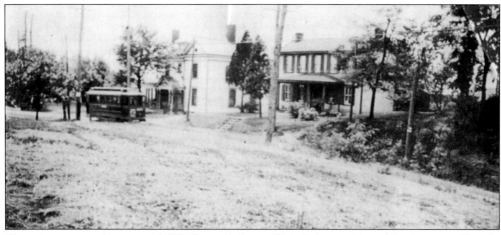

This picture was taken around 1905 from the lawn of Mt. Lebanon United Presbyterian Church, looking at Washington Road toward Bower Hill Road. The trolley is passing the Schreiner house.

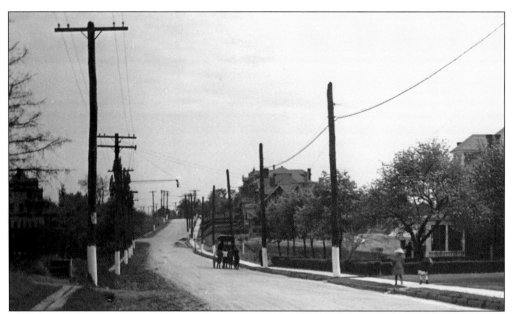

In 1870, Coal Hill and Upper St. Clair Turnpike Road was renamed Washington Road. When it was paved in 1897, it became the community's first macadam road. This picture was taken in 1910, looking south from about where Washington Elementary School now stands.

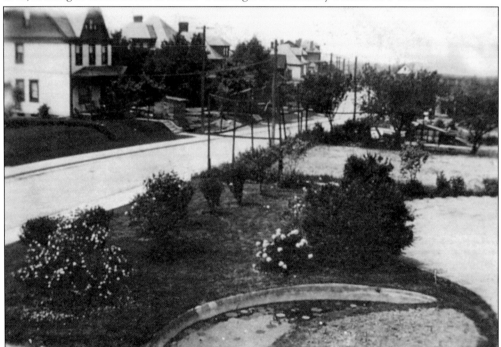

Academy Avenue, pictured in the early 1900s, was named for a school that stood on the street before the Civil War. Chris Williams, who moved to the street in 1924, said in a 1982 *Mt. Lebanon* magazine article, "An organ grinder with a little monkey used to come. The German band would come along and play. Hucksters with horse and wagon yelled at the top of their voices—'Eight quarts of strawberries for a dollar! Corn twelve cents a dozen!' "

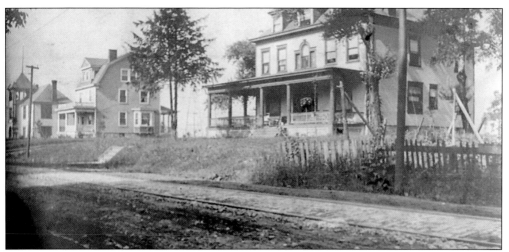

Before it was the community's central business district, Washington Road—between Cedar Boulevard and Academy Avenue—was a residential area. This c. 1912 photograph shows the Rafferty house in the foreground and the two-story white frame Ammann Avenue schoolhouse, built in 1895 for first through fourth graders, at far left.

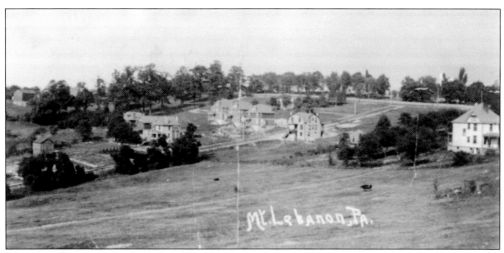

The white house at the far right of this early-1900s postcard is now Rollier's hardware store. The line of trees at the top screens the view of Mt. Lebanon Cemetery. A cow stands in the field. Carl Singhouse, who built a home on Cochran Road in 1924, said in a 1982 *Mt. Lebanon* magazine article, "One day you'd see a cow grazing in a field; the next day there'd be a house built there." (Courtesy Marian Wilson.)

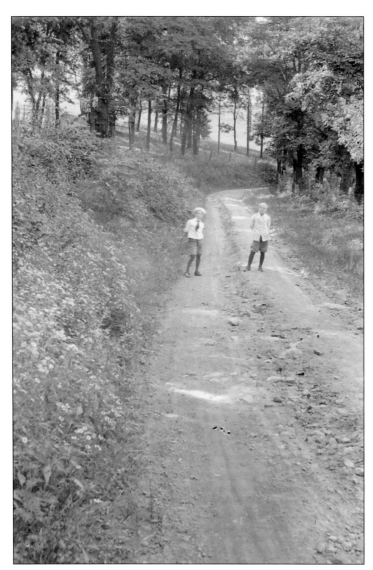

These unidentified boys stand on Bower Hill Road in 1915.

This c. 1910 picture was taken from Washington Road looking down Bower Hill Road at some of the newly constructed houses. In 1909, the *South Hills News* claimed the "magnificent houses with their spacious grounds make the Bower Hill Road a popular place for high class homes for suburbanites . . . it has all the attractions in view and breathing space and country surroundings, which appeal to the lover of things bucolic."

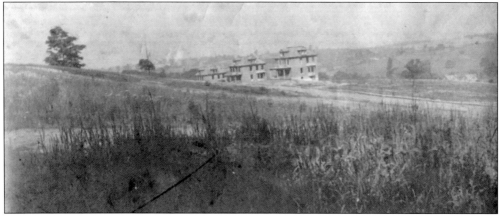

This picture shows Ammann Avenue (now Cedar Boulevard) in 1916. Ferne Horne, who grew up on the street, remembered in a memoir, "There was such a heavenly quiet and peace on our dirt street. All we could hear was the faint clanging of the street cars, the pealing of the school bell on weekdays, a rare passing of an automobile, which brought all the small fry to their front yards to stare in wonder."

This is Cedar Boulevard at Cochran Road in 1932.

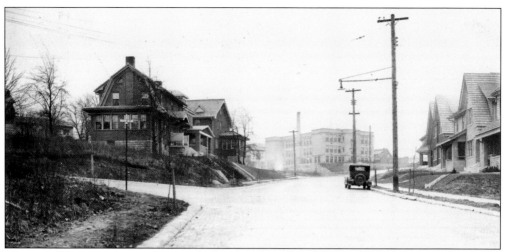

This c. 1925 picture depicts the view looking up Beverly Road toward Lincoln School.

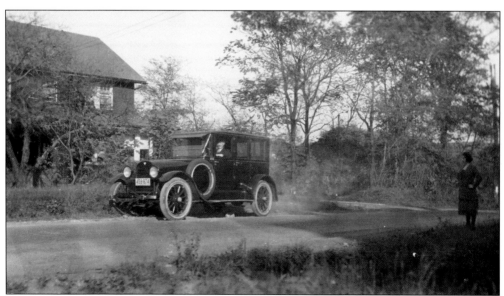

In 1912, there were reportedly only six cars in Mt. Lebanon. Even so, in June 1912, solicitor Samuel Schreiner suggested setting speed limits for automobiles and posting notices of dangerous points on the roads in an effort to avoid lawsuits. This picture was taken outside the B.K. Elliott home at 33 Castle Shannon Drive. The house was later torn down to build Mellon Middle School.

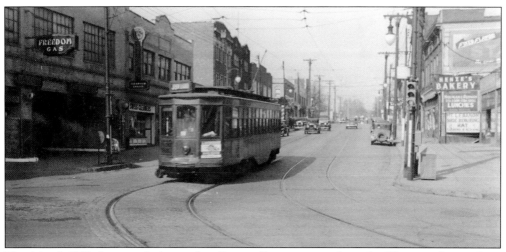

This March 1933 photograph shows a low-floor trolley car approaching the Clearview Loop, where it would turn around and head back to Pittsburgh. The trolley first came to Mt. Lebanon on July 1, 1901, but the track ended at Cedar Boulevard (a shuttle at Alfred Street took people into Castle Shannon). The cost for a one-way ride was 1.5¢. (Courtesy Miller Library, Pennsylvania Trolley Museum.)

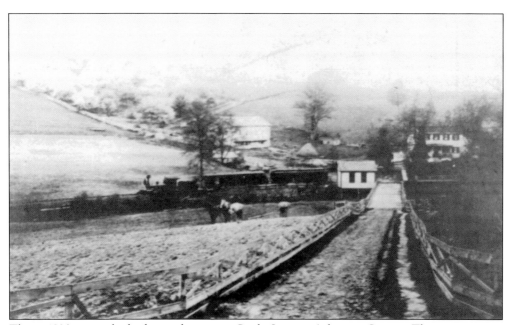

This c. 1890 picture looks down what is now Cooke Lane to Arlington Station. The narrow-gauge Pittsburgh Southern Railway was built in 1878 to connect Washington, Pennsylvania, to Temperanceville (now the West End).

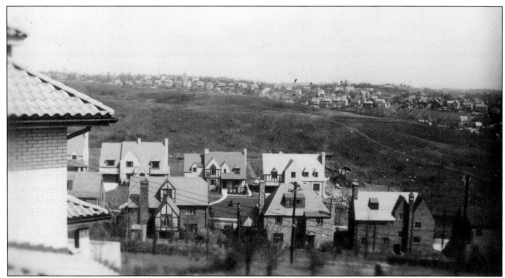

Bryson Schreiner took this c. 1935 picture from the window of his house at 42 St. Clair Circle. The houses in the foreground are on Rocklynn Place; Mission Hills is in the background.

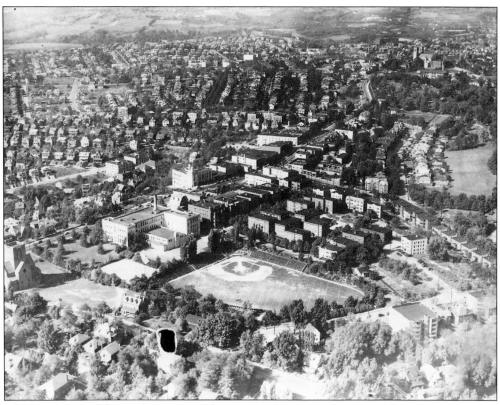

This aerial view of the Washington Road area was taken in 1936. One year later, construction of Mellon Junior High began in the large open space to the left of the Washington School field.

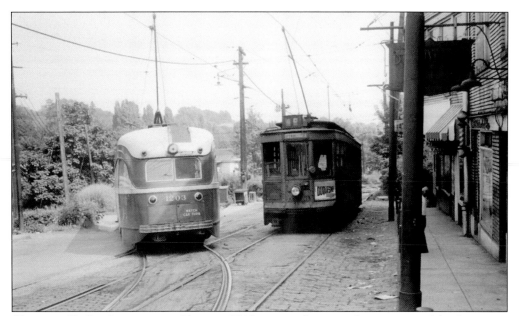

Clearview Trolley Loop, pictured here in 1946, was used to turn the cars around for the return trip to Pittsburgh. The loop was completed in 1921. The older car—called the "Dinkie"—at right ran between Mt. Lebanon and Castle Shannon on a single track. The shops in the Clearview Loop included Andy's Bar, a popular hangout after a long day of work. (Courtesy George Gula collection; photograph by William Volkmer.)

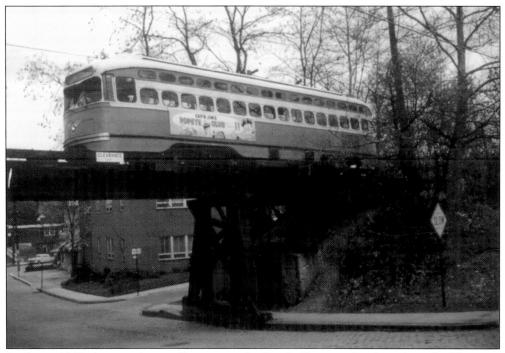

In this c. 1960 photograph, a trolley crosses the Castle Shannon Boulevard trestle. (Courtesy Dave and Julie Davis.)

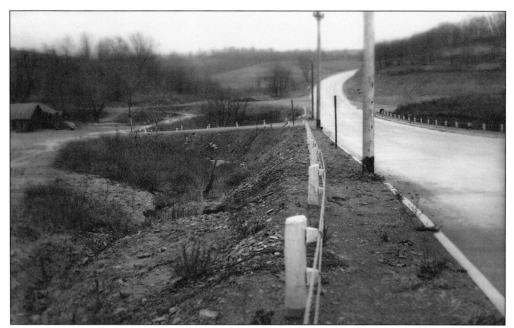

Washington Road near the intersection with Connor and Gilkeson Roads was a pretty lonely-looking place in the 1930s and 1940s. The Lebanon Lodge is visible at left.

A car turns onto Cochran Road from Washington Road in the 1940s.

Most kids today have never seen a telephone booth like this one that stood on Washington Road in the 1970s. Thanks to the Internet, that mailbox may soon become a relic as well. The Washington Square condominiums were built behind this building in 1981.

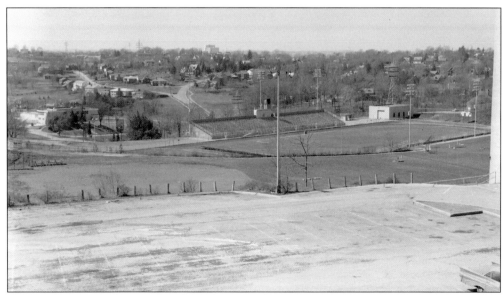

This 1967 photograph was taken from the Mt. Lebanon High School parking lot while looking across the football field to Greenhurst Drive. The recreation center and pool are at left. (Courtesy Melissa Good Wagner; photograph by Florence Good.)

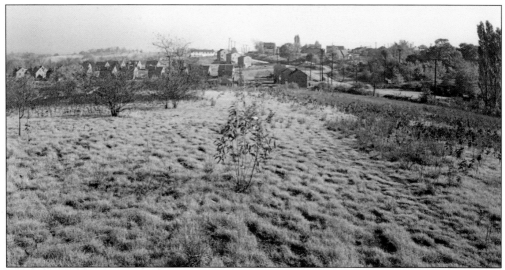

This c. 1952 photograph shows the plot of land on Bower Hill Road that became the site of St. Clair Hospital after the Silhol family who owned the land donated it to the hospital. (Courtesy St. Clair Hospital.)

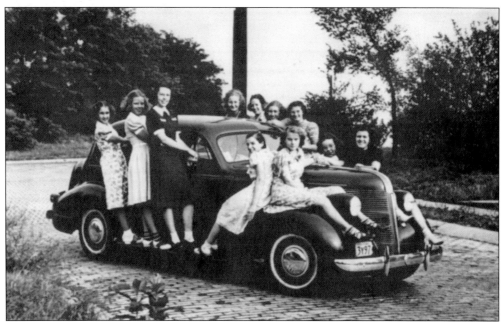

Girls can't resist a cool car, as shown in this photograph taken in 1939. Pictured here are, from left to right, (first row) Betty Jane Vail, Sally McFall, Barbara Bacon, Rosie Eckenrode, and Elly Eckenrode; (second row) "Pudge" Waechter, Petie McFay, Mabel Poster, Joan Daker, Janet Scott, and Lorraine Kolb. The driver is Stanley Waechter. (Courtesy Sally McFall Moore.)

While growing up in the early 1900s, Sara Long Lewis Ewalt often traveled the then-unpaved Bower Hill Road by horse and buggy. Ewalt wrote in a memoir that when she was growing up, the road was "either slippery or dusty" and that on one side of the road there was a two-plank boardwalk on a high bank. After the addition of Jefferson Elementary and Middle Schools (pictured in the background), residential developments, and a busy four-lane highway, this April 1967 photograph of Bower Hill Road would be virtually unrecognizable to Ewalt. The empty field in the picture's foreground—once the farm of John and Mary Goodboy Dickson—would eventually be developed by the United Methodist Homes, erasing one more vestige of Mt. Lebanon's farming past. (Courtesy Melissa Good Wagner; photograph by Florence Good.)

Discover Thousands of Local History Books
Featuring Millions of Vintage Images

Arcadia Publishing, the leading local history publisher in the United States, is committed to making history accessible and meaningful through publishing books that celebrate and preserve the heritage of America's people and places.

Find more books like this at
www.arcadiapublishing.com

Search for your hometown history, your old stomping grounds, and even your favorite sports team.

Consistent with our mission to preserve history on a local level, this book was printed in South Carolina on American-made paper and manufactured entirely in the United States. Products carrying the accredited Forest Stewardship Council (FSC) label are printed on 100 percent FSC-certified paper.

MADE IN THE USA